M A R Y

IMAGES OF THE HOLY MOTHER

MARY

IMAGES OF THE HOLY MOTHER

by Jacqueline Orsini

CHRONICLE BOOKS

SAN FRANCISCO

cover VIRGIN OF THE IMMACULATE
CONCEPTION *[detail]*
Francisco de Zurbarán
ca. 1638, Spain, oil on canvas

back cover [left] THE MADONNA OF HUMILITY
Lippo di Dalmasio
ca. 1389, Italy, unknown pigments on wood

back cover [middle] MADONNA OF PORT LLIGAT
[VERSION 1]
Salvador Dalí
1949, Spain, oil on canvas

back cover [right] VIRGIN FLANKED BY ARCHANGELS
GABRIEL AND MICHAEL
19TH C., Ethiopia, painted wood

page vi MADONNA AND CHILD WITH STS.
LAWRENCE AND JULIAN *[detail]*
Gentile da Fabriano
ca. 1400, Italy, tempera on wood panel

page viii VIRGIN WITH GARLAND
Sandro Botticelli
15TH C., Italy, tempera on wood panel

page xiii VIRGIN AND CHILD
18TH C., Goa, India, gold leaf and
paint on wood

Text copyright © 2000 by JACQUELINE ORSINI
All rights reserved. No part of this book
may be reproduced in any form without written
permission from the publisher.
Pages 95–96 constitute a continuation of copyright.

Library of Congress Cataloging-in-Publication Data:

Orsini, Jacqueline
 Mary : images of the Holy Mother / by
 Jacqueline Orsini.
 p.cm.
 Includes bibliographical references.
 ISBN 0-8118-2850-6
 1. Mary, Blessed Virgin, Saint—Art. I. Title.

N8070 O74 2000
704.9'4855—dc21
 00-022361

Printed in Hong Kong
Designed by ALETHEA MORRISON

Distributed in Canada by
Raincoast Books
9050 Shaughnessy Street
Vancouver, British Columbia V6P 6E5

10 9 8 7 6 5 4 3 2 1

CHRONICLE BOOKS LLC
85 Second Street
San Francisco, California 94105
www.chroniclebooks.com

The author would like to thank the following people
for their assistance in the creation of this book.

Dr. and Mrs. George Alderman, Jenifer Blakemore,
Julie Castiglia, G. Benito Cordova, Janet and
Walter Dunnington, India M. L. Dunnington, Gerhard
Gruitrooy, Nicholas Herrera, Thomas Lee Jones,
Martin Collins Kelly, Betty More Krebs, Leanna
Lee-Whitman, Library of the Museum of International
Folk Art, Charles Mann, Ana Pacheco, Jack
Parsons, The Spanish Colonial Arts Society, Yvonne
Dreux Thomas

Special thanks to Alan Rapp and Alethea Morrison
of Chronicle Books

CONTENTS

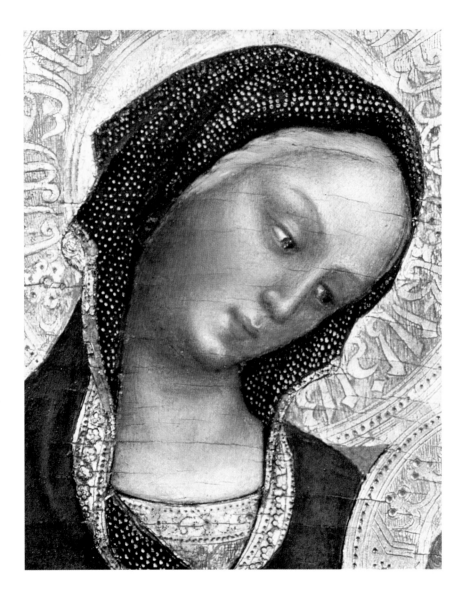

LOOKING AT MARY

by Jacqueline Orsini

How does the world see the personage variously known as the Virgin Mary, the mother of Jesus, the Mother of God, the Christian Madonna?

Some, including Pope Paul VI (in office 1963–78), call her a mediatrix between her devotees on earth and the divine. Postbiblical teachings of the Catholic Church continue to nourish an interest in Mary that has not waned over twenty centuries. Beyond theology, Mary has inspired artisans of all talents, crusaders, saints, prisoners, pilgrims, and mothers.

The Virgin Mary is both one woman and many; it seems that the more the Church has presented definitions of her role over the centuries, the more personae she has assumed. There are several Marys mentioned in the New Testament; this book features images of the one who was the mother of Jesus. Mary is honored in many specific votive advocations: a few of the many hundreds are the Virgin of the Rosary, the Virgin Mary of Guadalupe of Mexico, Our Lady of Victory, Our Lady of Sorrows, the Virgin of Wayfarers and Mariners, and Our Lady of Solitude.

Some of these embodiments of Mary in art include the iconography of the doctrine of the Immaculate Conception. This belief was established in 1128 following theological debates. The doctrine holds that Mary's birth was divinely appointed and that she came from her mother's womb free of all mortal sin. This immaculate purity prefigured her role as the mother of Jesus. In 1854, Pope Pius IX promulgated the dogma of the Immaculate Conception, *Ineffabilis Deus Munificentissimus*. In this role, the Madonna is portrayed in various ways, but she invariably clasps her hands in prayer. She can be depicted in local or idealized landscapes and in early representations, flowering from the Tree of Jesse. Importantly, the morally spotless mother of Jesus is frequently shown standing above a sliver of the moon, clothed in the sun, and surrounded by stars (as is the Woman of the Apocalypse cited in Revelations 12:1 with which an Immaculatist

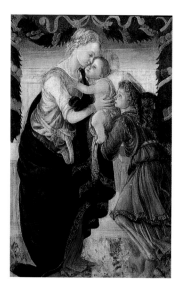

image is often conflated). In these interpretations of the Madonna, her mantle is usually blue and her dress white or a pastel shade. Artists frequently enhance Mary's lofty virtue with clusters of roses, angels, and clouds to indicate that she floats above the mundane. The de Zurbarán painting in the National Gallery of Dublin, Ireland, fully illustrates this advocation.

The primary sources of information about Mary are the sparse references to her in the New Testament. The Bible is silent on the subject of Mary's birth, marriage rite to Joseph, and death. Scripture, however, does define her role as an intercessor and the mother of the Christ Child. Her facial features and other physical details are similarly absent from the New Testament. European images of Mary, the mother of Jesus, rely on the little that can be gleaned from the New Testament and legendary interpretations of the canon. The Gnostic Gospels discovered at Nag Hammadi, Egypt, in 1945 were not readily available to the public in English until 1977—and depictions of Mary in those influential but shadowy sectarian texts are as scant as those in the New Testament.

Christian theologians inferred as much as they could to shape Mary's role into their religion, but it is through the popular imagination and abundant celebratory artworks that she flourishes. The visual arts offer a material focus for her otherwise invisible, ineffable presence as an influence on Western culture.

In the Qur'an (surah 19) there is mention of a Maryam (Mary) in which Allah advises Mohammed to "make mention in the Book" [presumably the Qur'an] of Mary, mother of Jesus,

who is further confounded with a reference in the same surah to a Miriam in Exodus. This arcane muddle is laden with challenges for Muslim and Christian scholars alike. Islamic Mariology does not add much to understanding the Christian Mary in art. Muslims believe that Mary gave birth after shaking a palm tree to let fresh dates fall, not in the classic nativity scene.

Early mention of the mother of Jesus in the New Testament is in Saint Paul's letter to the Galatians (4:4). The evangelist does not name her but simply notes that Jesus was "born of a woman." This passage is still accepted by scholars as written in the middle of the first century A.D. Mary is not cited again in Pauline writings. The gospel according to Saint John (2:1–7) also does not mention Mary by name but only makes reference to the mother of Jesus.

In Acts (1:14) Mary is named, and we learn that she prayed after the ascension of Jesus. Here as an orant, one who prays; she assumes an active role.

The first three gospels of the New Testament—known to biblical scholars as the synoptic gospels—each mentions Mary by name. Saint Mark (3:31) identifies Mary in relationship to Jesus as "his mother" and later (6:3) as "the son of Mary." This evangelist gives her no further mention.

The Gospels according to Saint Matthew and Saint Luke are the principal sources in the Bible of Marian data along with details of the life and infancy of Jesus; both seem to have been written at least four to five decades after the birth of the Christ Child. Present research holds that Matthew's gospel precedes that of Luke chronologically. In Chapter One, Matthew details the genealogy of Jesus and honors Mary as the wife of Joseph, the mother of Jesus. In verse 1:20, Saint Matthew narrates "For that which is conceived in her is of the Holy Ghost." The Gospel according to Saint Luke informs us of Mary in greater detail than any other biblical reference. It is in his verses that artists have found inspiration over the centuries. We can "see" the Madonna in the images in Luke's narrative. In his account, Mary speaks on four occasions. Her most noted words are the *Magnificat* in 1:46–55 where she says "My soul doth magnify the Lord," and, significantly, "behold, from henceforth all generations shall call me blessed."

The lacunae in the Bible of the Virgin's birth and death are covered in later documents. An apocryphal gospel appended to the New Testament in the second century A.D., The Book of James, or the *Protoevangelium Jacobi,* chronicles the birth of the Mary whom the Holy Spirit blessed as a woman perpetually free of sin. Origen (A.D. 185–254), a Church Father who lived shortly after the compilation of this postbiblical record, took this text to be proof of Mary's virgin birth. At the end of her earthly life, she is received bodily into heaven after her dormition,

a scene in which she closes her eyes to the world and is thereafter assumed into the presence of the Godhead. The first accepted mention of Mary's death is in the Latin translation of the Greek codex the *Pseudo Melito,* dated ca. A.D. 500. A millennium and a half later, the dogma of the Assumption was promulgated from the Vatican as dogma by Pope Pius XII in 1950.

Luke delineated much of the Christmas story that is celebrated in famous canvases, in simple greeting cards, and in nativity depictions. However, there is an assumption that animals stood in homage to the newborn Jesus in his cradle. Perhaps there were animals eating at their manger in the birth stable, yet no beast is cited in Luke's gospel. This almost-hallowed zoology is the product of artistic imagination working to render a credible nativity setting. The same steps beyond words have given us images of Mary produced by paintbrush and chisel.

The personhood of Mary has given rise to a vast diversity of devotions, prayers, pilgrimages, ballads, and visible representations. Without question, knowledge of the Madonna has been universally disseminated because of the visual arts. Images of her are the optical focus of devotional activities around the world. Though her physical appearance and clothing are not mentioned in scripture, she has been presented in form and dress by centuries of artistic invention, assumptions of modes drawn from local venues, and convention. This absence of mention of her appearance in the Bible has been replaced by a myriad of glorious portraits from around the world. Her wardrobe is thus splendidly diverse, devoid of monotony, and not a uniform. It is the artist who has dressed Mary and not those who penned the Bible.

There is no seminal portrait of Mary made during her lifetime for artists to copy. This obvious, but often unrecognized, fact offers the artist some liberties to produce the sequence of major events in the life of Mary drawing from her role in scripture, tradition, folklore, and official doctrine. The ethos and era that nourishes the artisan, materials at hand, and the mysterious power of creativity explain, in part, why no two images of the Madonna are alike. It is the artist who gives unique expression to the Marian biography while mindful of the symbolic heritage that accompanies her. The inscrutable powers of the divine are often cited as moving behind the historical scene, moving the hands of an artisan who claims guidance from heaven.

Marian portraiture has evolved over the centuries, testimony to the unique view of any artisan who presents her. To view the historical sweep of Marian art is to adventure as a witness the discarding of old forms for ever newer visions of the Virgin. In the twentieth century, the obvious changes in depictions of the Virgin Mary are reflected in a general acceptance of Modern, post-Modern, sacred, and secular idioms of expression. The flourishing of the publishing

industry has made her images from the past, and in the present, available around the globe. Many are those who have been made aware of her role in Christianity and in general history, often beyond the Catholic world; Anglicans, as do others, honor her in name and icon.

Mary. It is she who is with her son throughout his life, from birth to crucifixion, and no biblical figure other than Christ is more often portrayed in art than she is. The sequence of events narrated in the gospels give us a biography of the Virgin's life, albeit without dates. Her devotion, mercy, steadfastness, purity, and compassion are ideals represented in many of her likenesses.

The major milestones in Mary's early life are the focus of countless artistic representations: her birth, her mother Anne's presentation of her at the temple, her education, and her marriage to Joseph. Her role as the mother of Jesus takes on meaning when the angel Gabriel announces that she has been selected by God to give birth to the savior. St. Luke tells of Mary sharing this news of her destiny with her kinswoman, Elizabeth, who will become mother of Saint John the Baptist. Further, the Madonna is depicted in many maternal venues after the birth of Jesus: at the manger, where wise men from the East bearing treasures (according to Matthew) or shepherds (according to Luke) come to honor the babe; holding and nursing the Christ Child; nestling Jesus on the flight into Egypt; and last grieving at the foot of the cross.

By the third century, Marian iconography began to bear the Christian message and her pivotal role in the church. At the Council of Ephesus in A.D. 431, the Virgin Mary was declared to be indeed the mother of God (Theotokos), though this expression was not declared dogma by the early church. This action affirmed the dual nature of Jesus as human and divine; it also defined Mary's role.

Mary in art is often glorified as Queen of Heaven, with and without a crown, on a throne. She is comfortable in an idyllic pastoral setting, standing above the moon, surrounded by stars and a sunburst. Angels cluster about her, as do garlands of flowers. By the late middle ages, the Virgin holds a rosary; she is at peace in the passivity of solitude or active as a protector of pilgrims or the disenfranchised. These latter details become integrated, over time, into the inventory of Marian symbols.

As the eyes travel across various images of Mary, they see different details in each projected likeness. For example, her hair can be bobbed or long; reddish, black, or blonde; hidden or fully displayed; curly or straight. Her mantle may be blue, black, crimson, lavishly embroidered, or starkly simple; sometimes it covers her head, other times it drops from her

shoulders; or it is left out, perhaps for another wearing. The artist, often drawing from local conventions of women's dress, may elect to wrap Mary in patterned brocade or gauze, velvet or flax. Jewels and other ornaments may embellish her clothing, or she may be rendered without such tokens of symbolic or material merit.

The colors of the clothes in the Madonna's wardrobe surpass any rainbow in infinite shades. Her clothing has meaning well beyond the fickleness of fashion. In the matter of presenting Mary, the local culture of the artist has exerted an influence upon her attire. It was not until 1649 that a Spanish painter, Francisco Pacheco in *Arte de la Pintura,* set down any rules concerning depictions of Mary. He urged artists to dress a fair-faced Madonna in a pink dress covered by a blue cloak. Since then, many artists have either been unaware of these regulations or elected to set them aside; others still adhere to these seventeenth-century guidelines.

In Marian compositions, the stars on the Virgin's mantle have both symbolic and decorative meaning. The Old Testament prophecy of the advent of a Messiah is found in Numbers 24:17, "there shall come a Star out of Jacob." But in the New Testament, the star is a symbol of the Epiphany. Both Christmas cards and renowned artists have portrayed the star as a symbol of the Nativity using Matthew 2:9 as authority. "Ave Maris Stella," a hymn attributed to Venantius Fortunatus of the sixth century A.D., helped to popularize the star as a symbol for Mary (star, or *stella,* may be St. Jerome's mistaken translation for *stilla,* a drop). In Eastern Rite Christian churches, Mary's cloak is often trimmed with a golden star or stars, which, according to some interpreters, represent her everlasting purity before, during, and after the birth of Jesus. The star symbol is an accepted symbol integral to many images of the Mexican Madonna of Guadalupe. The original image featured no stars on the Virgin's cloak. In fact, unknown artists added all the gold decorative elements (including the stars) to the 1531 "miraculous portrait" after the 1560s. It is unattested speculation to associate star motifs on Guadalupe's cloak with pre-Columbian female iconography, for Aztec lore does not contain such biblical and European symbolism.

The crown often placed on Mary's head, be it starkly simple or ornate, is authorized by artistic convention. This regal attribute is not to be confused with the solemn tradition of a coronation ceremony, in a sacred setting, that celebrates the Madonna's place in heaven. The tradition of the coronation of Mary has deep precedent emerging from the art of the medieval period. By 1143 this visual convention appears in the mosaic-lined dome in the Church of Santa Maria in Trastevere near Saint Peter's Basilica in Rome. The crown symbolically links the Madonna to the reign of heaven over the people on earth.

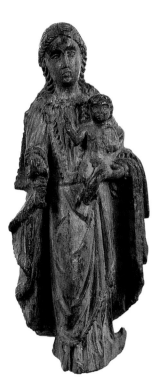

Ultimately, it is her facial expression that gives soul to a portrait of Mary. The backdrop or landscape is usually from the homeland of the portrait's creator; clouds and other ethereal visual devices often suggest a heavenly scene, and an unmarked setting frees the artist to concentrate on the subject. Additional figures in a composition usually accord with the biblical narrative, other sacred lore, or a patron's identity. Decorative details such as in niches and frames, fruits and flowers, swags and garlands, gems and jewels, and other embellishments add richness to many compositions.

Some of the earliest depictions of Mary, such as that found in the Roman catacombs dating to the fourth century A.D. (plate 66), are portraits in frontal poses, without depth modulation and few if any decorative embellishments. Mary holds the infant Jesus but does not interact with him as she looks out at the world with a fixed stare. She looks more like a Roman maiden in this fresco than the sensitive virgin with a lowered head that Christendom has come to know.

By the fourth century A.D., visual arts of Byzantium began to flourish. Although the Virgin continues to be rendered in a frontal pose, she is newly flanked by saints or angels, in glowing mosaics. From this point forward, artists began to depict Mary in a variety of roles and

biographical scenes: the Annunciation, the Nativity, and the Flight to Egypt stem from biblical references; Mary praying, nursing the Christ Child, and as the Mother of God were new inferences developed in the popular mind. The mosaics of Ravenna, Venice, Rome, and elsewhere in Italy are in the Byzantine tradition and offer superb testaments of the visual arts reaching into the realm of the mystical. By this time, Mary comes pictorially alive, her unique position in Christianity visually celebrated.

The next major artistic development, somewhat overlapping the Byzantine era, was the Romanesque period that extended roughly from the tenth century into the late thirteenth century. The Virgin was celebrated in illustrated manuscripts, enamel and gemstone inlays, and church sculpture. The tone of these works of art is often one of somber reverence. However, during the Gothic age, from about 1300 and well into the 1500s, soaring cathedrals and resplendent altarpieces feature Mary holding Jesus, clutching a rosary, bowing to be crowned. By now she is the Queen of Heaven, and abundant use of gold and lush colors enhances her image that is often larger-than-life. The mother of Jesus has evolved well beyond the formal images from the catacombs a millennium prior.

During the Renaissance, Mary acquires emotional depth, intensity, three-dimensionality, and elements of humanity hitherto absent. Her body becomes supple. The settings that she inhabits in paintings are local landscapes, not just heavenly milieux. As was customary at the time, earthly patrons and donors often appear in the corners of portraits. From the seventeenth to the early nineteenth century—the Baroque era—sweeping visual flourishes added imaginative force to the entrenched efforts of the Counter Reformation. To convince the eye was to convince the mind and soul. The Catholic Church felt its first order of business was to ignite spiritual conviction against an increasingly secularized and Protestant world. The final stage of royal excess, the Rococo, did not embrace a marked interest in religious themes.

Black Madonnas find their legitimate places in the heritage of Marian images. Visually, a dark Mary can be compelling. Many black, or dark, images of Mary are the result of chemical changes caused by time and smoke from altar candles, encrusted soot, or other pollutants; they do not indicate a lost thread to paganism. Certain faces of the Virgin must be carefully evaluated for skin tones before assigning them to the Black Madonna files. One example is the portrait of the Mexican Virgin Mary of Guadalupe, said to have been miraculously imprinted on a Christianized Aztec's cloak in 1531. She has been casually labeled a Black Madonna, but to replicate the tones on her face, an artist would have to use pale shades of natural flesh tones

and light gray, not brown or black. Other dark Marys were authentic products of an artist's convictions coupled with time-honored local venerations of dark or Black Madonnas. The use of media at hand, such as certain woods and metals that darken with time and exposure, account for some black images. Artists' exposure to dark-skinned native or ethnic populations partially explains the tradition of the Black Madonna in religious art. There are those who believe that the bride who says "I am black, but comely" in the Song of Solomon (1:5) is in the same spiritual cadre of women as Mary, but they do so out of fancy, not fact. Equally speculative are the notions that Black Madonna icons express secret, dark, and hidden aspects of the feminine psyche. Theories of Mary sharing a Black Madonna typology with such figures as the Hindu goddess Kali are taking a bold leap into the realm of archetypal theory. To Christians, Mary was once a human; to Hindus, Kali has always been an abstract icon.

Speculations that the Virgin was, and still is, part of an ancient goddess cult are currently fashionable. It is important to keep in mind that Mary, to Christians, is not a reprocessed pagan goddess; she is the human mother of Jesus.

Cubist, modern, postmodern, and other twentieth-century trends have manifested their own Marian images; with so many opportunities available to the visual artist, Mary has been portrayed in an infinite variety of ways. The traditional rules of optical focus can now be broken and replaced by new visions of what an artist can realize as an image of Mary. But her essence remains the same across the centuries. Mary transcends the media, the temporal and regional restrictions, and human limitations that govern her image in any one era. The meaning of the icon outweighs the individual artist or epoch.

The eternal and the temporal meet in Mary's portraits. Each depiction tells her story as the unchanging vessel through which God's charity, refuge, love, mercy, and blessings are freely given. It is the artists throughout the centuries who help us to know Mary. As we look at Mary, she looks back at us through the eyes of art.

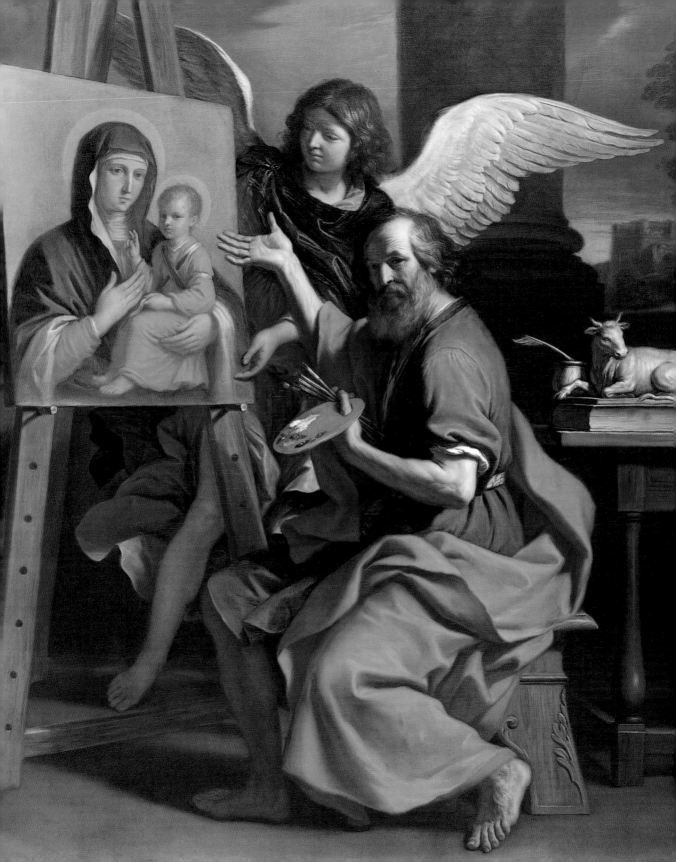

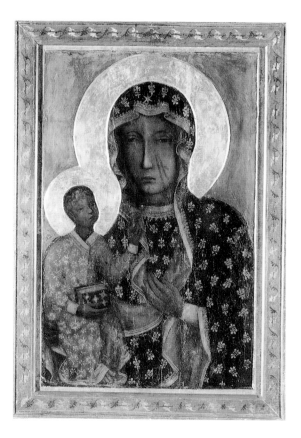

¹ST. LUKE DISPLAYING A PAINTING OF THE VIRGIN
Giovanni Francesco Barbieri, called Guercino
1652–1653, Italy, oil on canvas

²OUR LADY OF CZESTOCHOWA
legendarily attributed to St. Luke
date and origin uncertain, pigments and gilt on lime wood

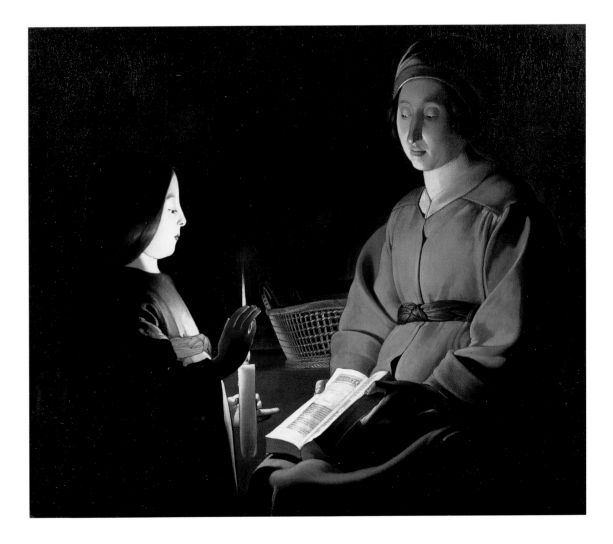

3 EDUCATION OF THE VIRGIN
Georges de la Tour
early 17ᵀᴴ C., France, oil on canvas

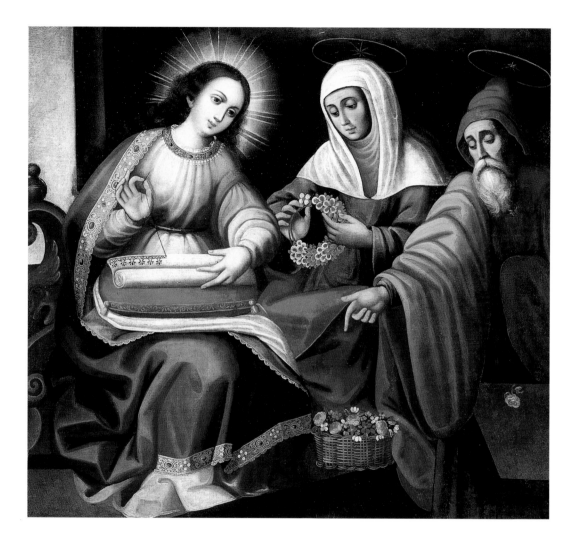

4 VIRGIN EMBROIDERING WITH STS. ANN AND JOAQUIM
Leonardo Flores
ca. 1690, Bolivia, oil on canvas

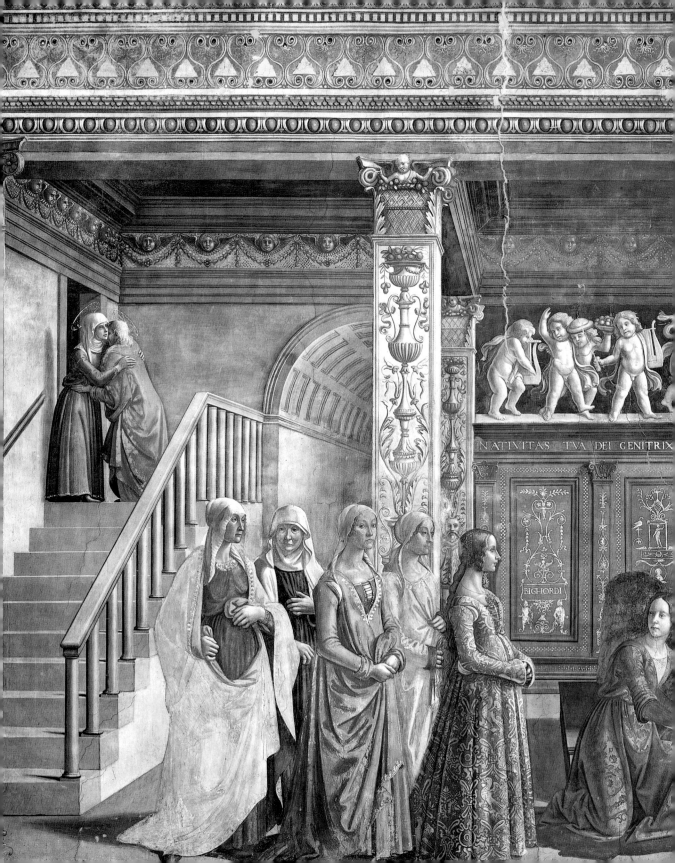

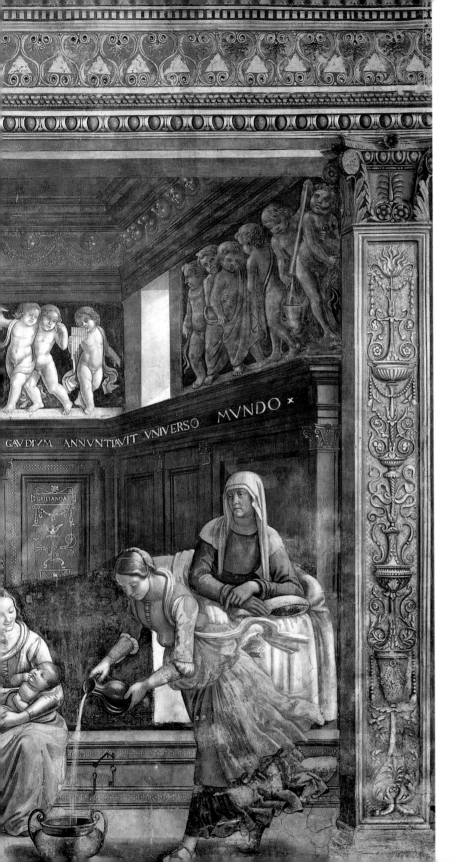

GAVDIVM ANNVNTIAVIT VNIVERSO MVNDO ×

GRILLANDA

5 BIRTH OF MARY *from the*
HISTORY OF MARY CYCLE
Domenico Ghirlandaio
late 15ᵀᴴ C., Italy, fresco

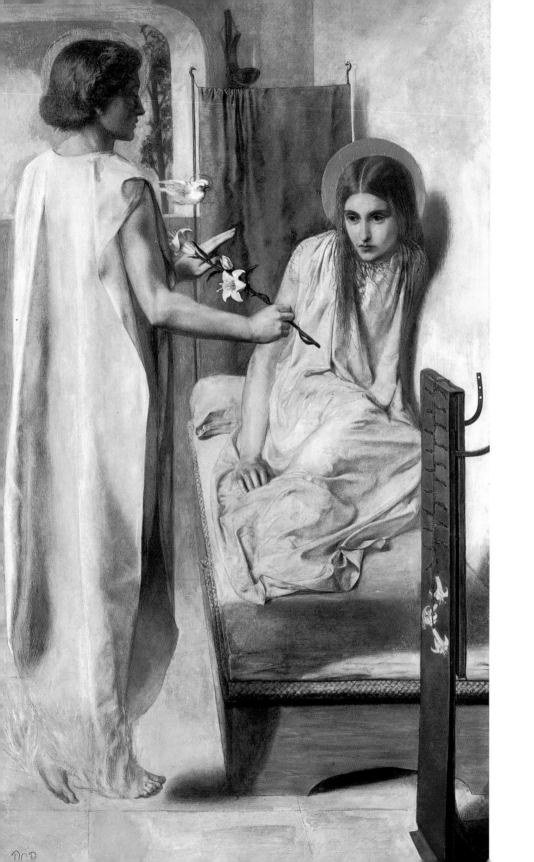

Fear not, Mary:
for thou hast found
favour with God.

6 THE ANNUNCIATION [ECCE ANCILLA DOMINI]
Dante Gabriel Rossetti
ca. 1850, England, oil on canvas

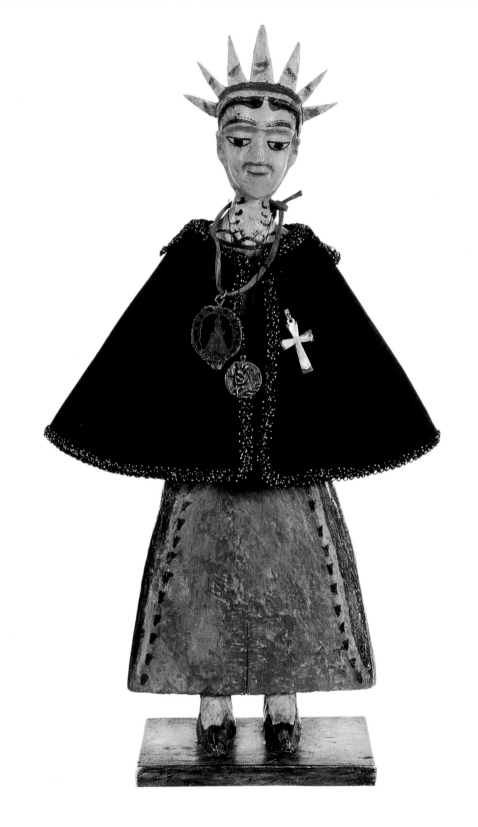

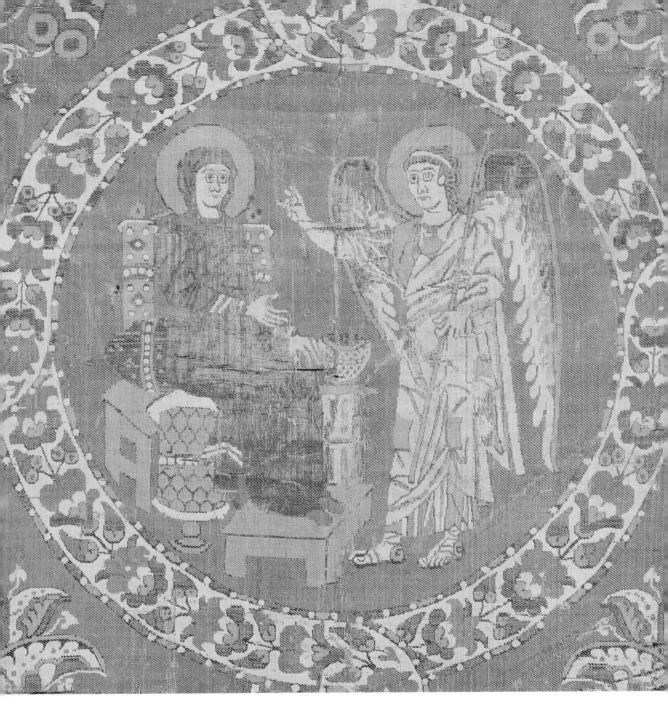

7 VIRGIN

José Benito Ortega
19ᵀᴴ C., New Mexico, milled wood, water-based paint,
gesso, added cloth and amulets

8 THE ANNUNCIATION
late 8ᵀᴴ–early 9ᵀᴴ C., Byzantine textile

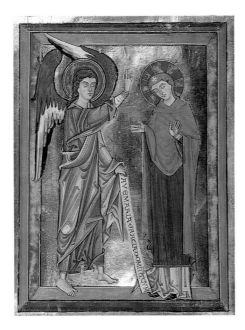

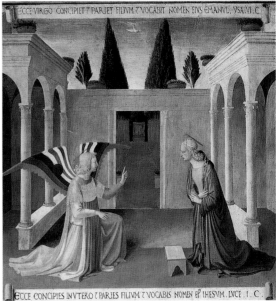

9 THE ANNUNCIATION
[miniature from a Würzburg Psalter]
ca. 1240, Germany, tempera, gold leaf
on parchment

10 THE ANNUNCIATION
Fra [Beato] Angelico
early 15TH C., Italy, tempera on wood

11 MADONNA AND CHILD
Andrea di Vanni
late 14TH C., Italy, egg tempera and gold on panel

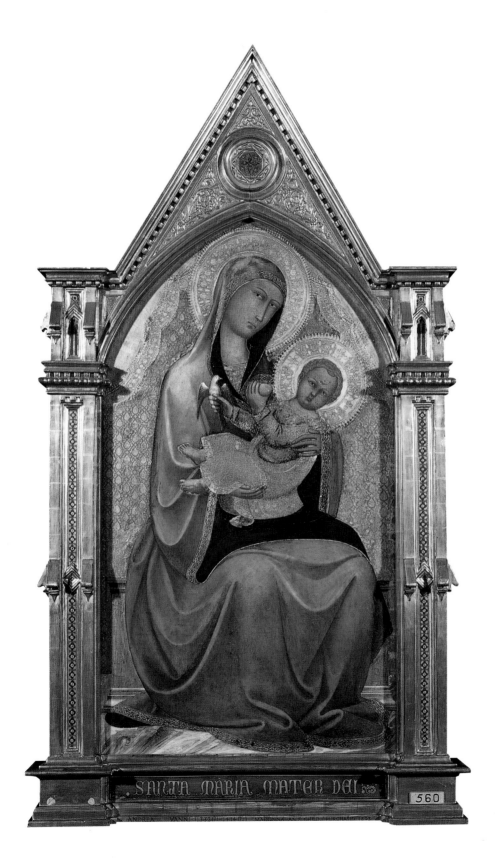

SANTA MARIA MATER DEI

560

ANDREA VANNI (1339(?)-1414(?)) MADONNA AND CHILD PURCHASED 1853

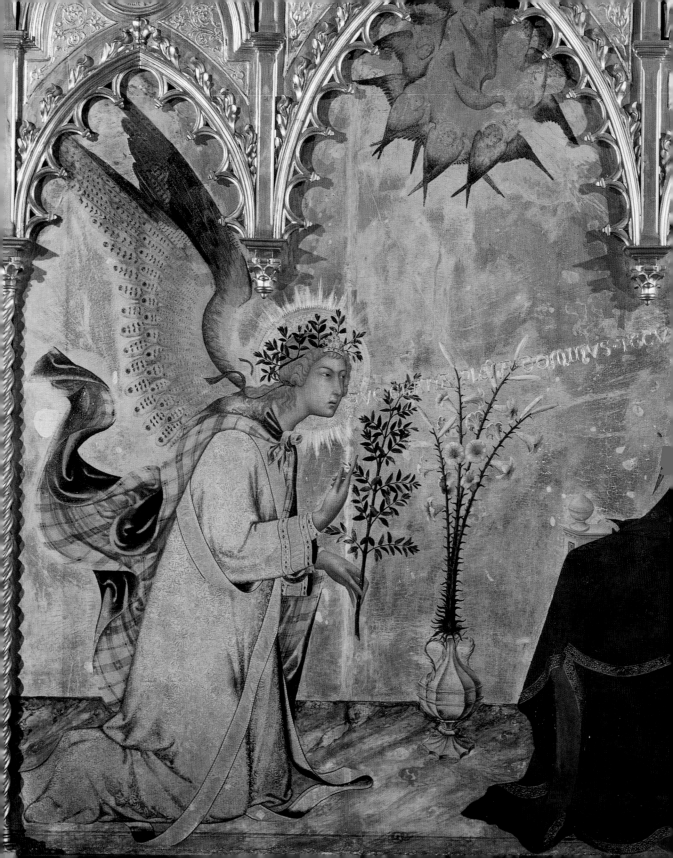

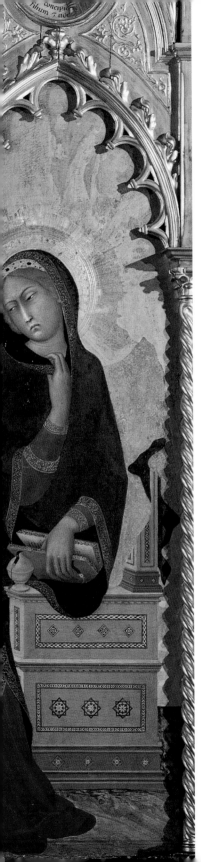

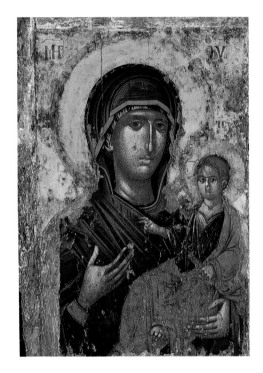

And, behold, thou shalt
conceive in thy womb,
and bring forth a son...
Then said Mary unto the
angel, How shall this be,
seeing I know not a man?

14 THE ANNUNCIATION
El Greco
1569–1570, Spain, tempera on panel

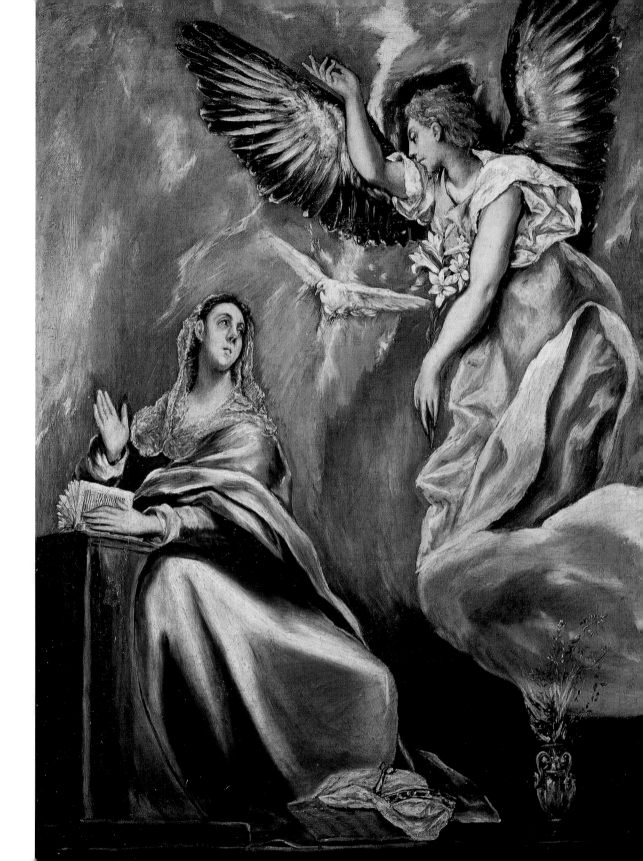

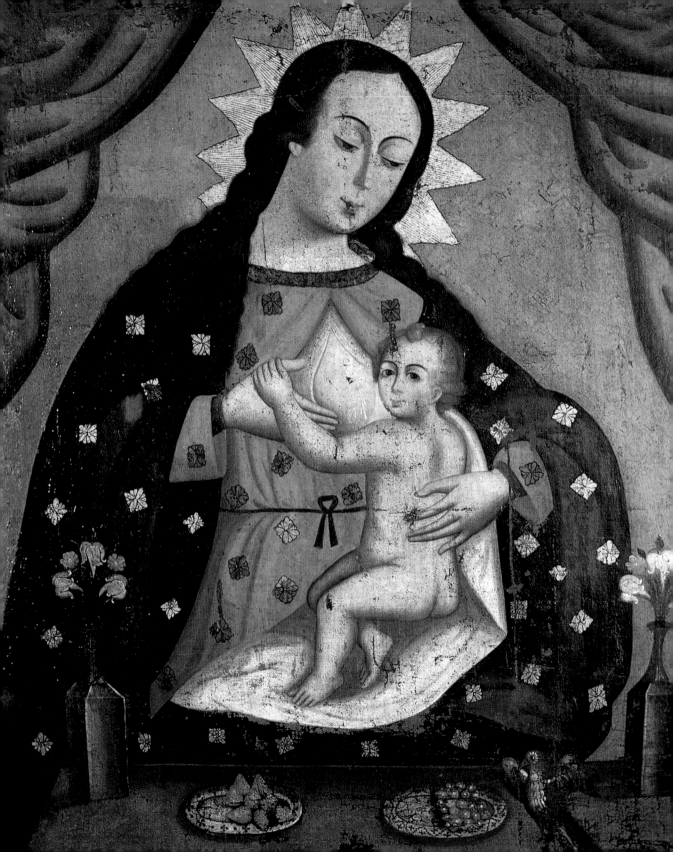

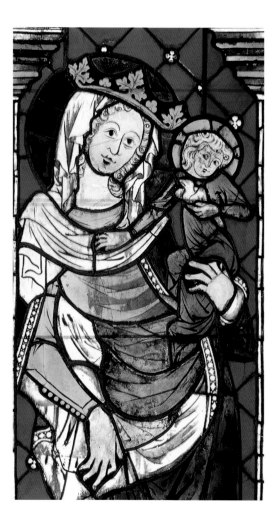

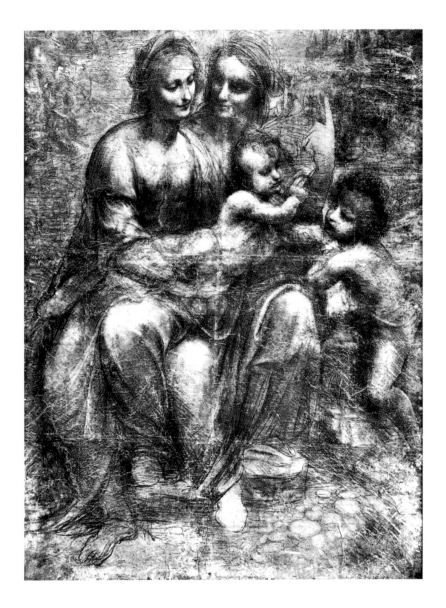

17 VIRGIN AND CHILD WITH ST. ANNE
Leonardo da Vinci
ca. 1500, Italy, black and white chalk on paper

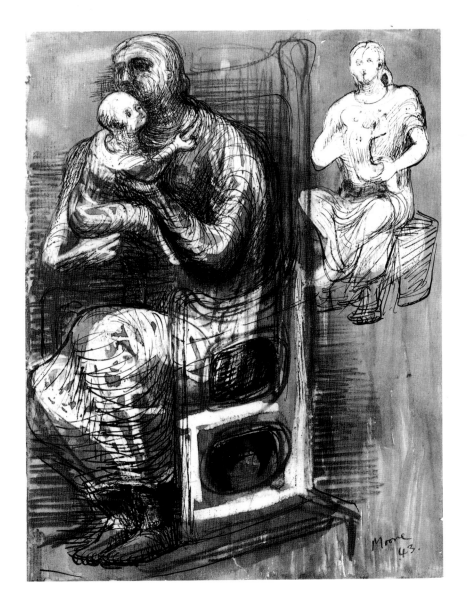

18 MADONNA AND CHILD
Henry Moore
1943, England, pencil, white wax crayon, watercolor,
black crayon, pen and black ink

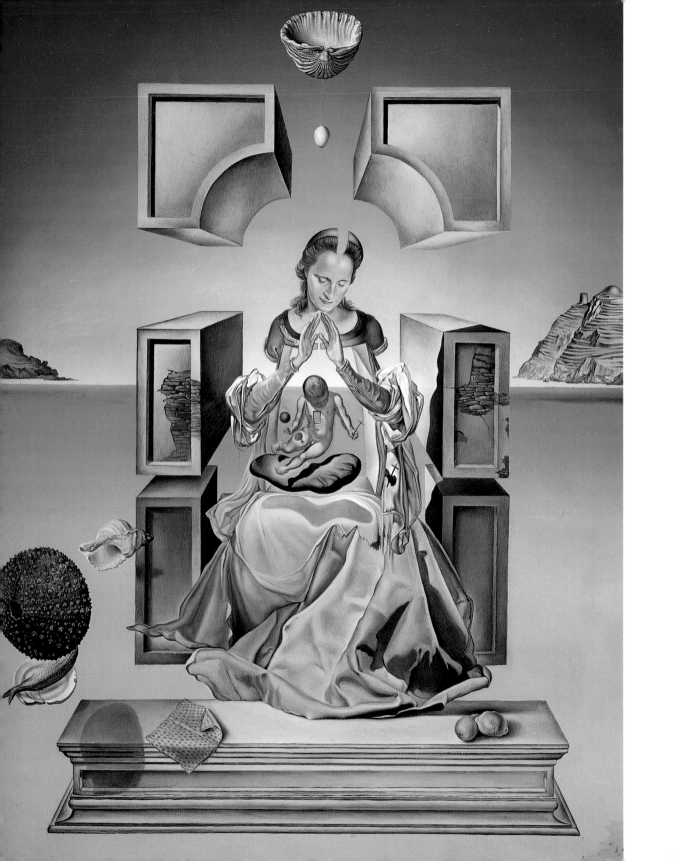

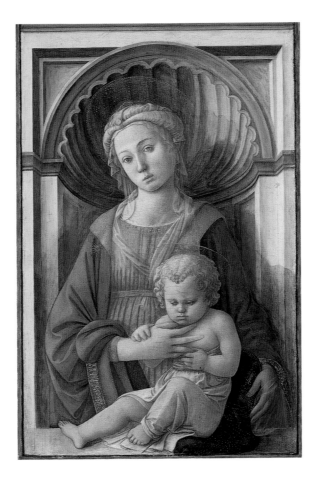

FRUIT OF THE WOMB

Blessed art thou among women, and blessed is the fruit of thy womb.

21 MADONNA AND CHILD UNDER THE APPLE TREE
Lucas Cranach, The Elder
1520–1526, Germany, oil on canvas

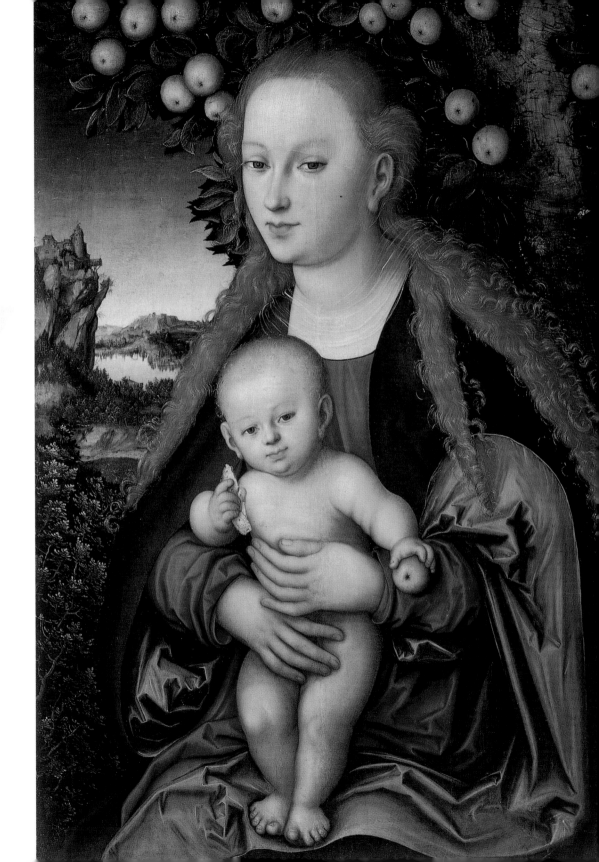

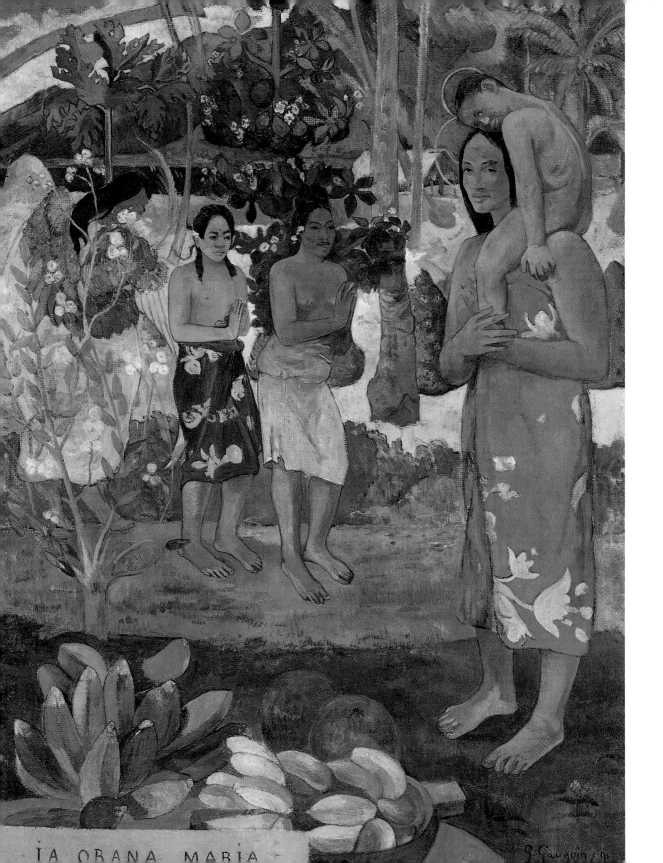

IA ORANA MARIA P. Gauguin. 91

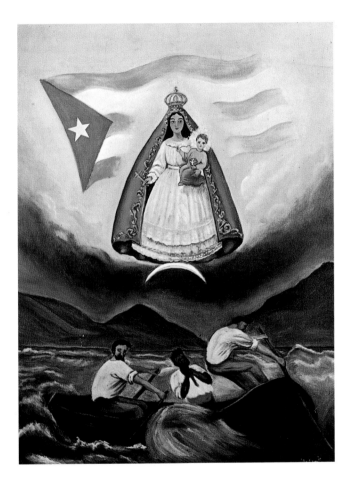

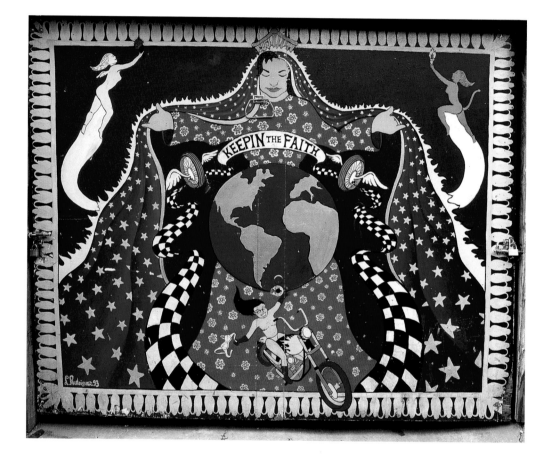

KEEPIN THE FAITH
L. Rodriguez
1993, Mission District, San Francisco, California, mural

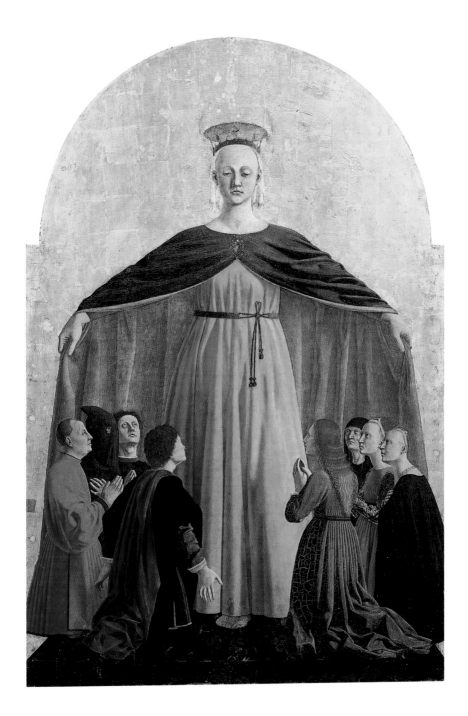

25 LA MADONNA DELLA MISERICORDIA
Piero della Francesca
mid-15TH C., Italy, pigment and gold on wood

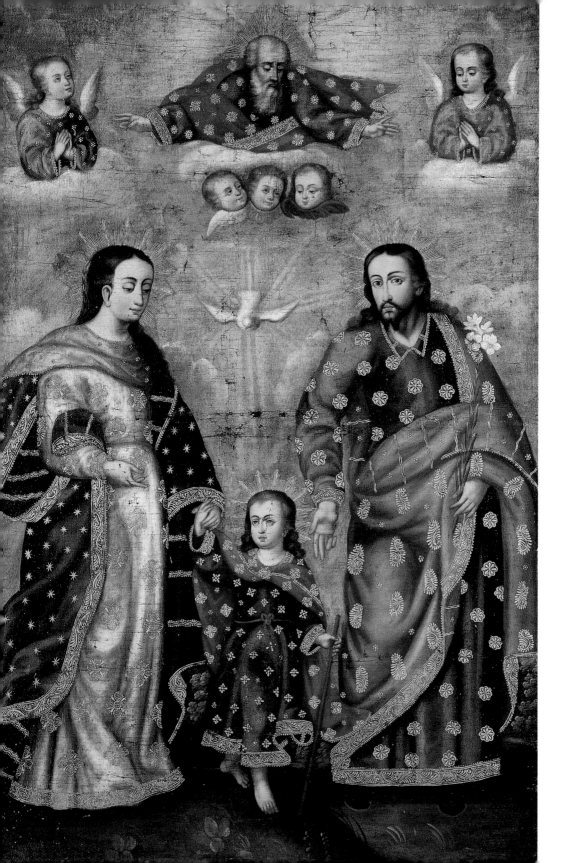

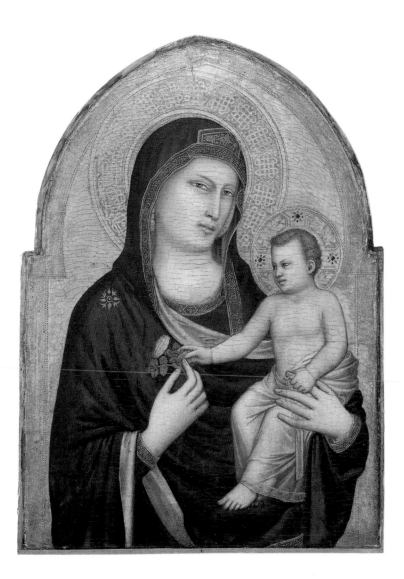

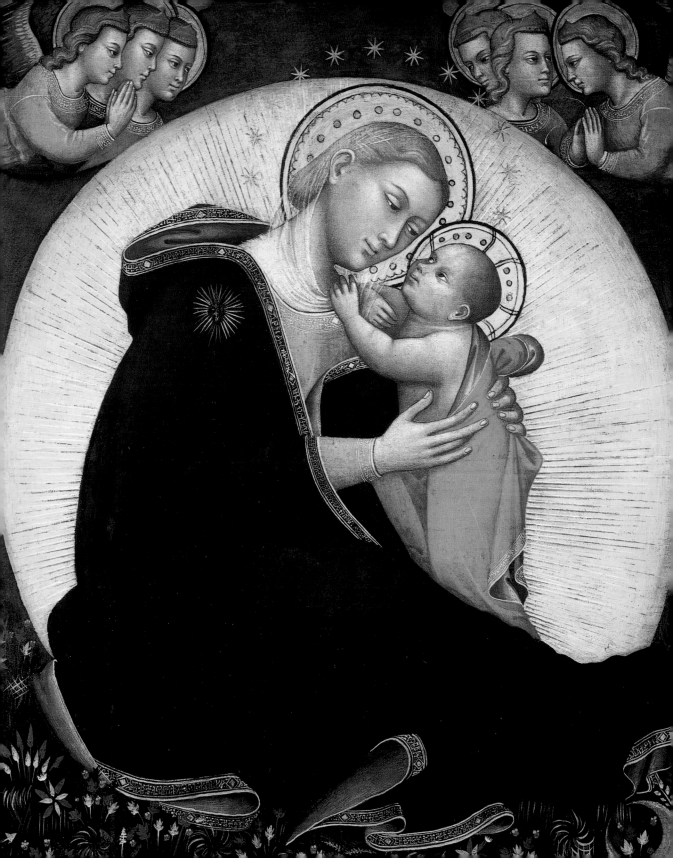

Behold, from henceforth
all generations shall call
me blessed.

28 THE MADONNA OF HUMILITY
Lippo di Dalmasio
ca. 1389, Italy, unknown pigments on wood

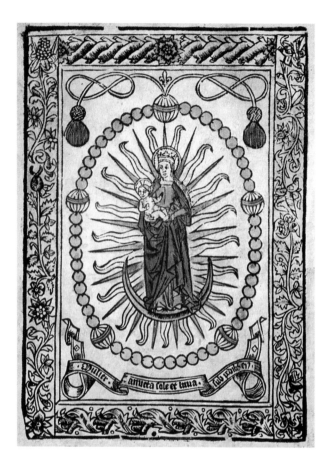

MADONNA AND CHILD IN A ROSARY
Savoy School
ca. 1490, France, hand-colored woodcut

VIRGIN OF THE APOCALYPSE
Workshop of the Master of the Amsterdam Cabinet
ca. 1480–1490, Upper Rhine, pot-metal
glass, white glass, vitreous paint, silver stain

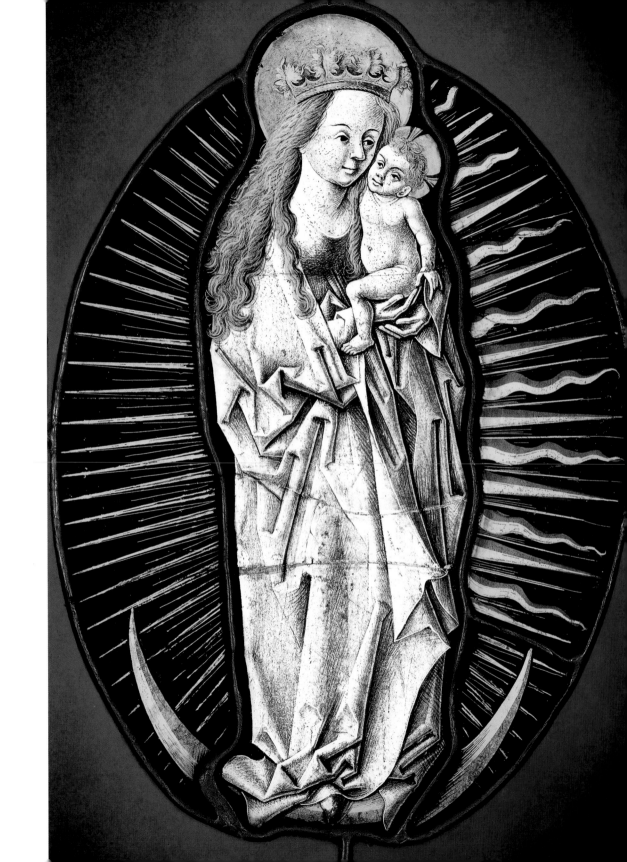

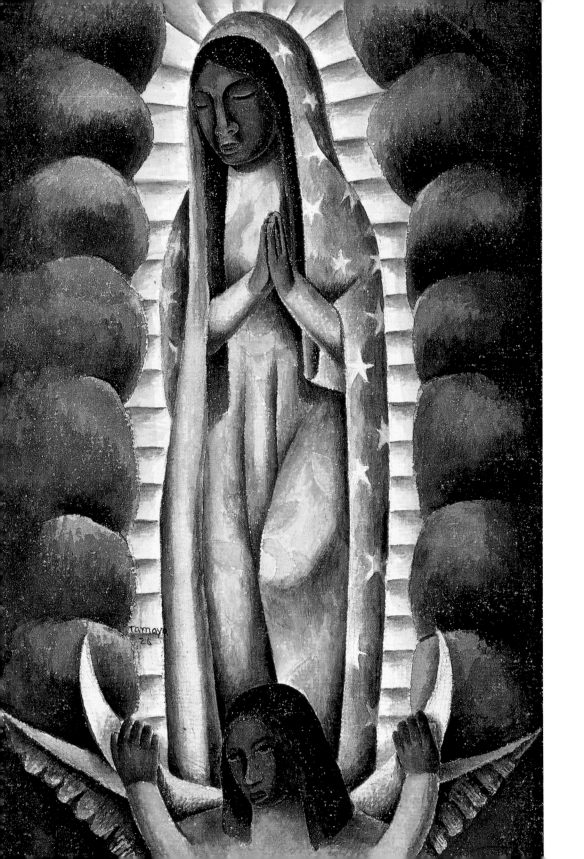

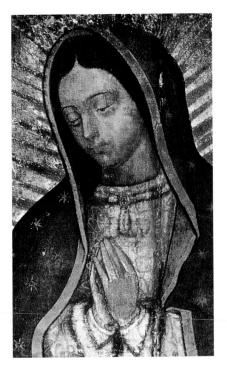

31 [opposite] OUR LADY OF GUADALUPE
Rufino Tamayo
20ᵀᴴ C., Mexico, gouache on paper

32 OUR LADY OF GUADALUPE
1531?, Basilica de Guadalupe, Mexico City,
unknown pigments on ayate-fiber cloth

33 MADONNA OF THE GARDEN
Nicholas Herrera
1999, New Mexico, organic pigments on wood

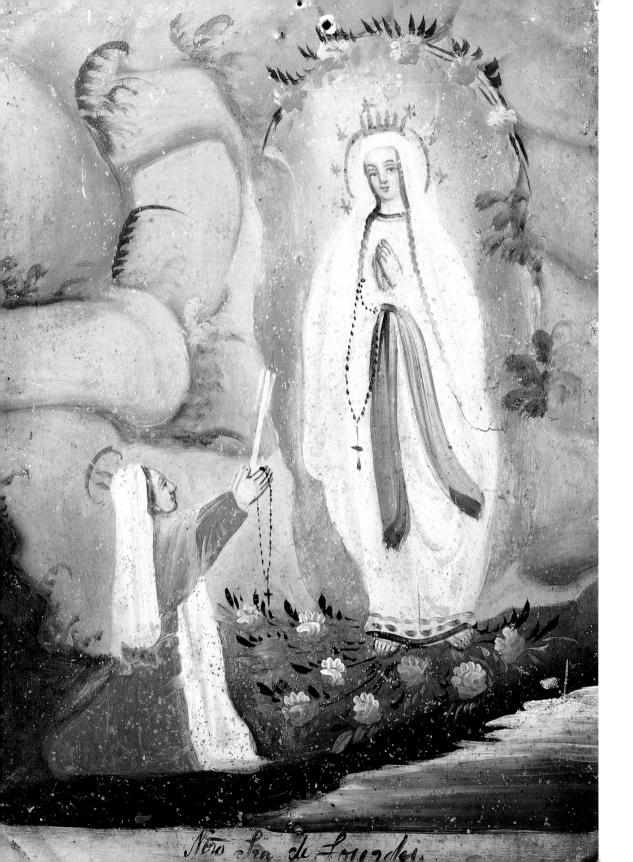

Ntra Sra de Lourdes.

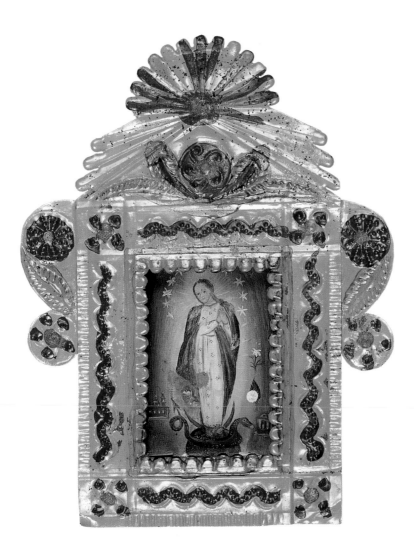

34 MARÍA APARENCIA AL GRUTA DE LOURDES
late 19TH C., Mexico, painted tin

35 OUR LADY OF THE IMMACULATE CONCEPTION
mid-19TH C., Mexico, painted tin

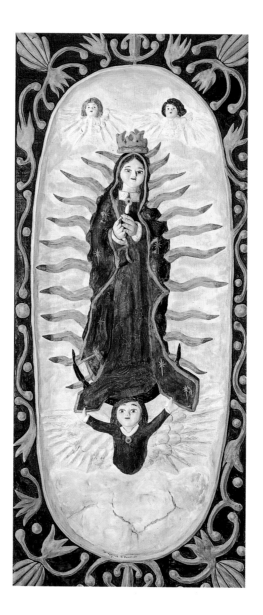

36 OUR LADY OF GUADALUPE
Gilbert J. Montoya, Jr.
1992, New Mexico, pigments on pine wood, gesso,
gesso clay, piñon varnish

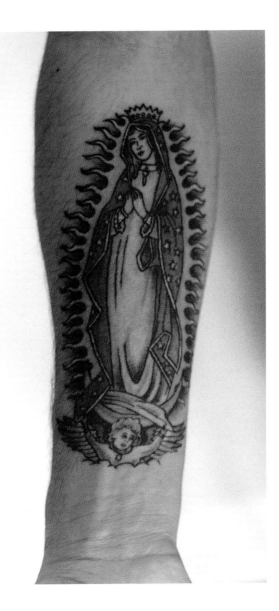

HOT ROD GUADALUPE
Good Time Charlie Cartwright
1997, California, tattoo

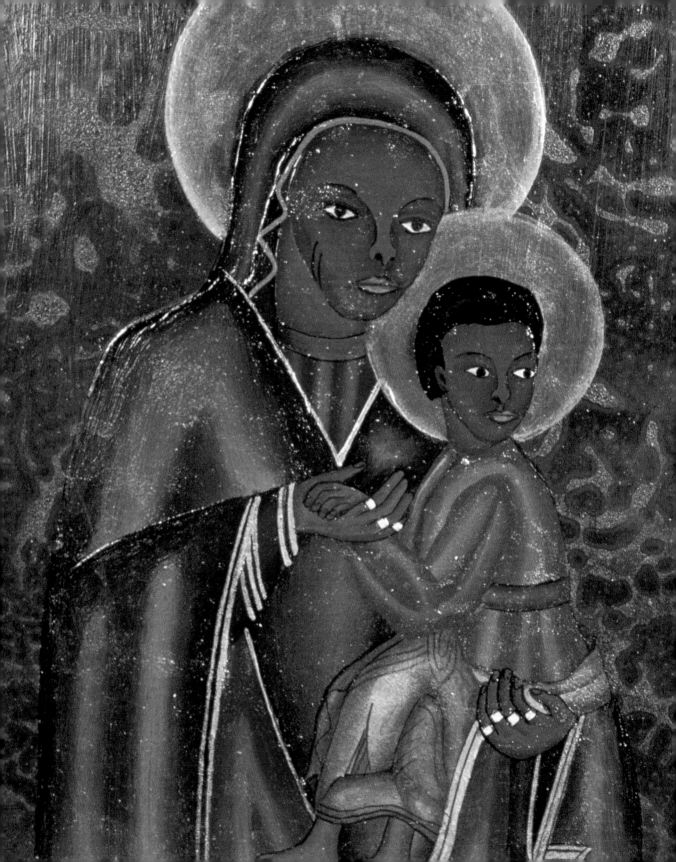

NO ROOM IN THE INN

And she brought forth her firstborn son, and wrapped him in swaddling clothes, *and laid him in a manger;* because there was no room for them in the inn.

38 MADONNA AND CHILD
late 19ᵀᴴ C., Haiti, medium not given

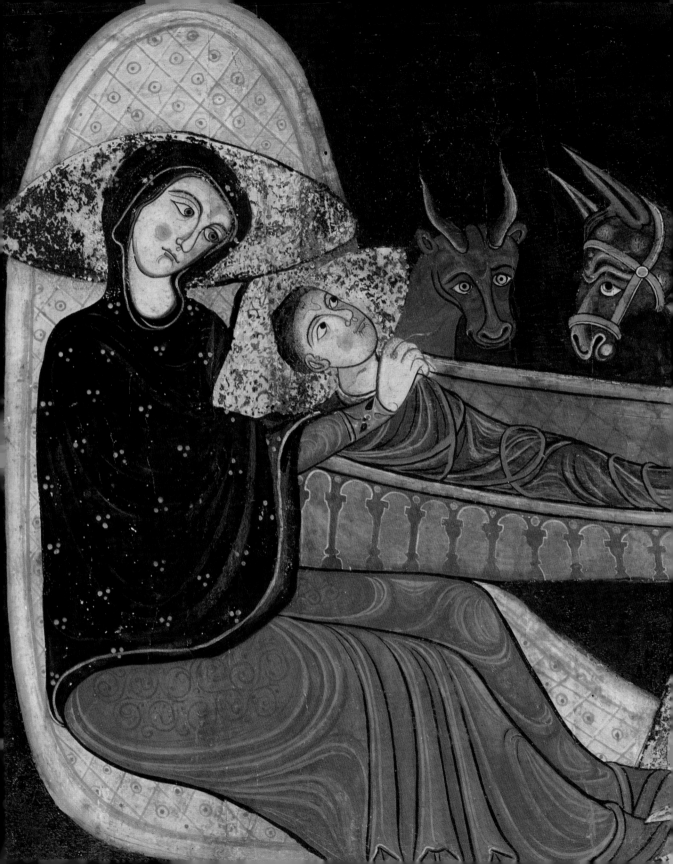

39 THE NATIVITY *from* LIFE OF THE VIRGIN
13ᵀᴴ C., Hermitage of Santa Maria,
[Avià] Barcelona, Spain, polychromed wood
and gilt stucco

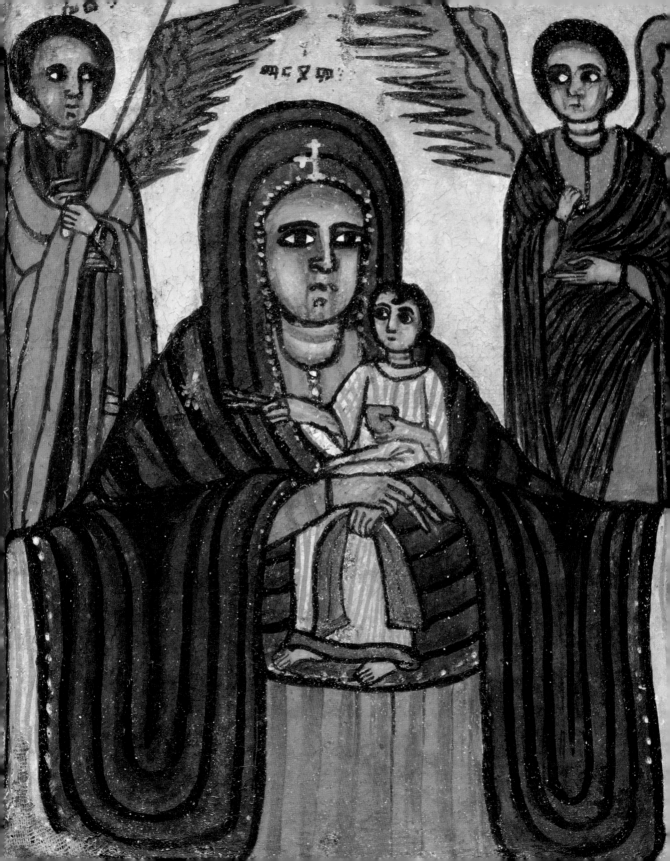

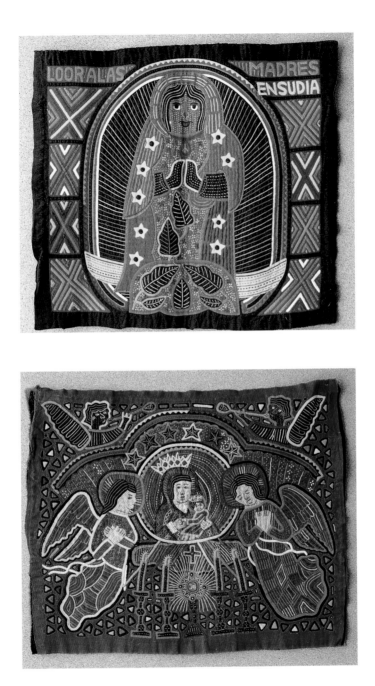

40 VIRGIN FLANKED BY ARCHANGELS
GABRIEL AND MICHAEL
19TH C., Ethiopia, painted wood

41-42 MOLAS *[cloth bodice panels]*
Kuna Indians of the San Blas Islands
20TH C., Panama, cotton appliqué

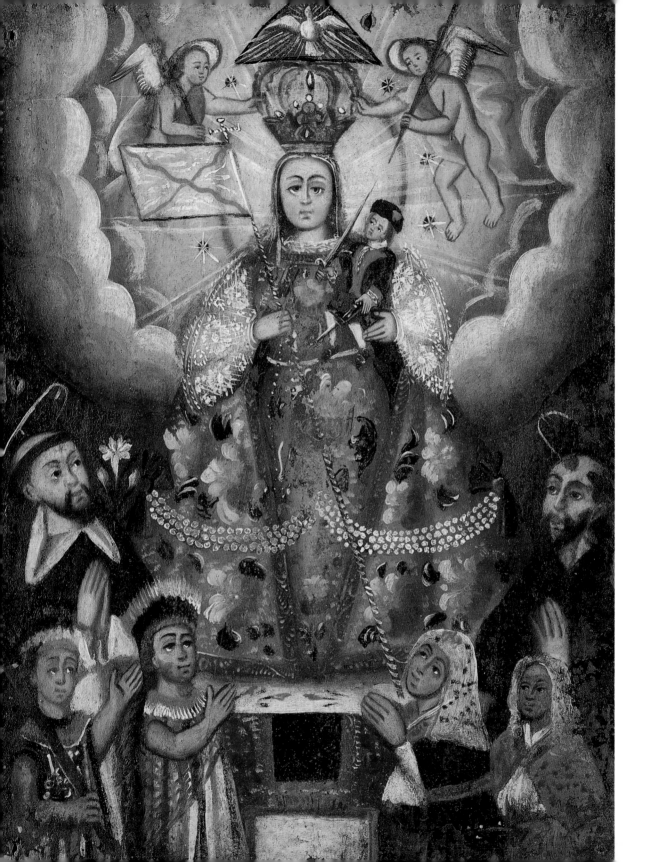

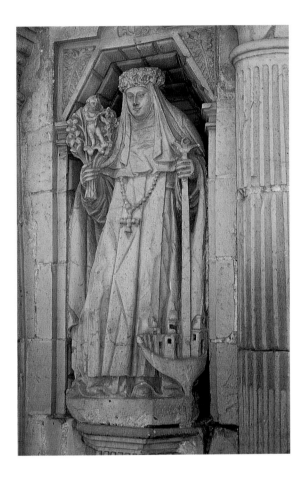

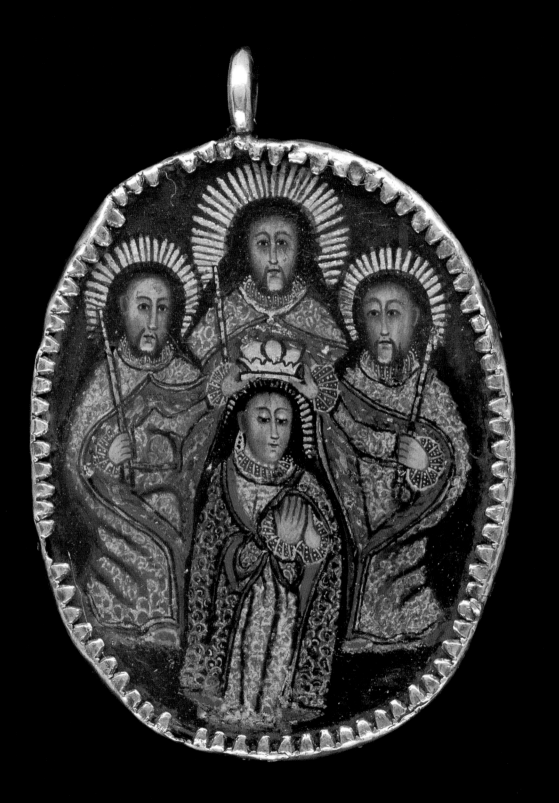

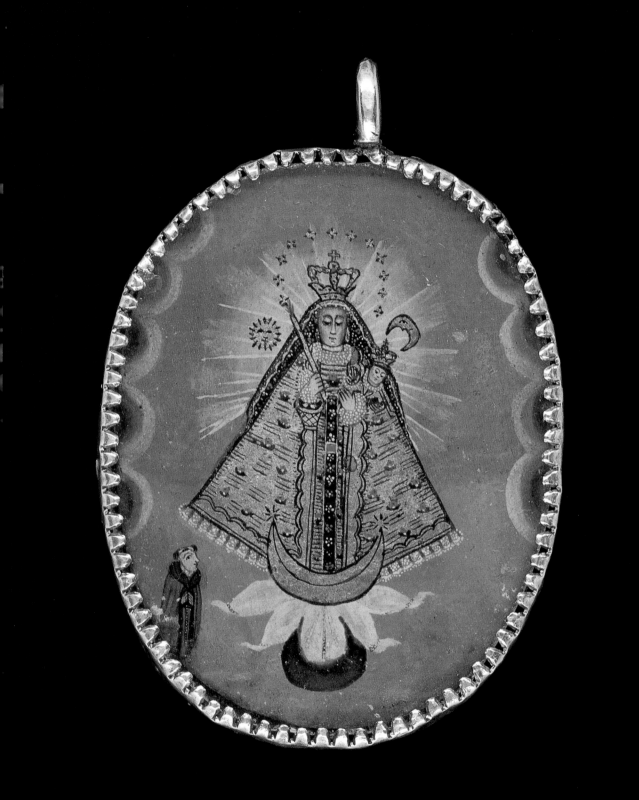

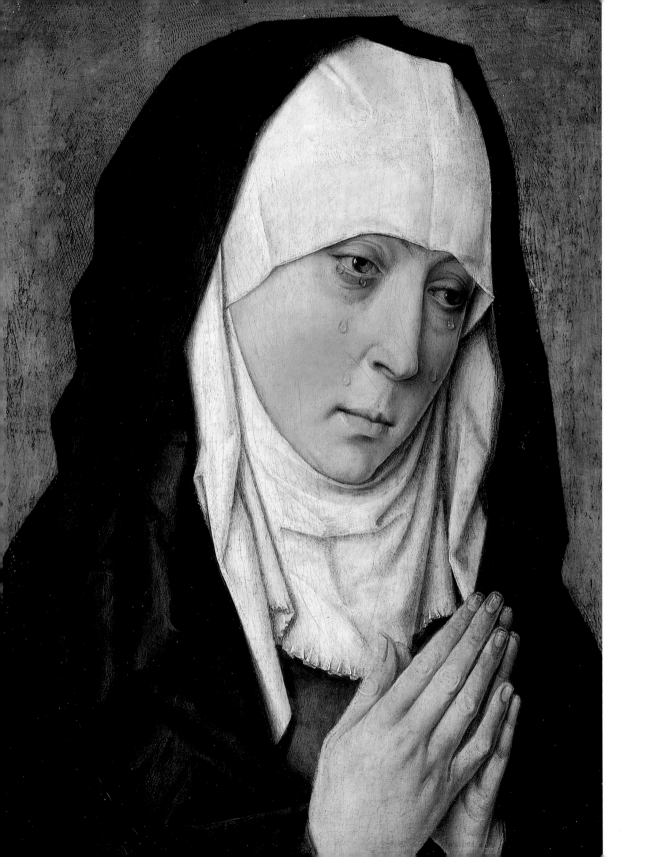

PIERCE THY SOUL

Behold, this child is set for the fall and rising again... (Yea, a sword shall pierce through thy own soul also,) that the thoughts of many may be revealed.

47 MATER DOLOROSA
Dierick Bouts
ca. 1460, Netherlands, oil on panel

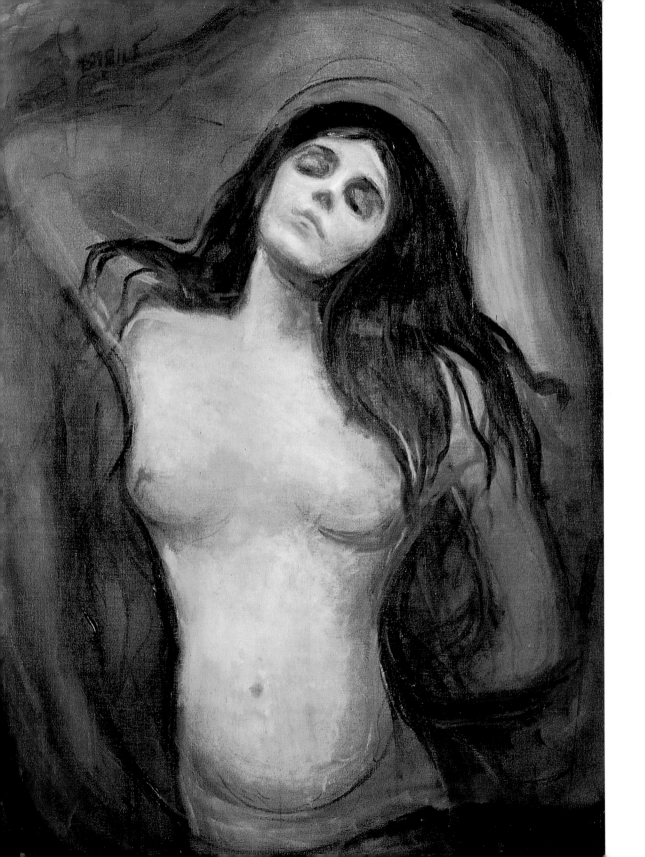

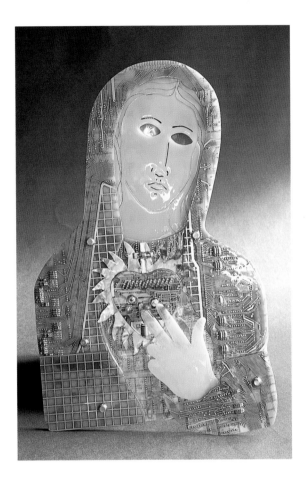

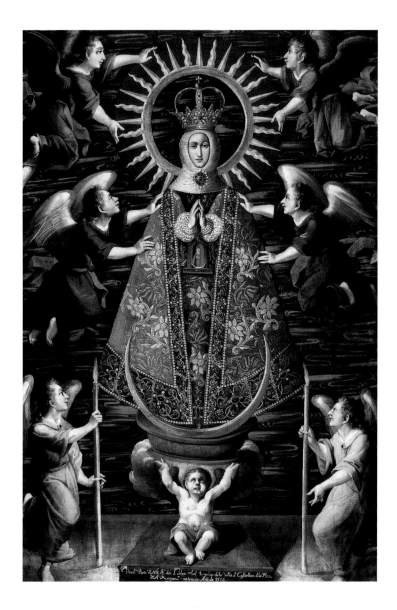

50 OUR LADY OF LIDON

Melchor Pérez de Holguín

1716, Peru, oil on canvas

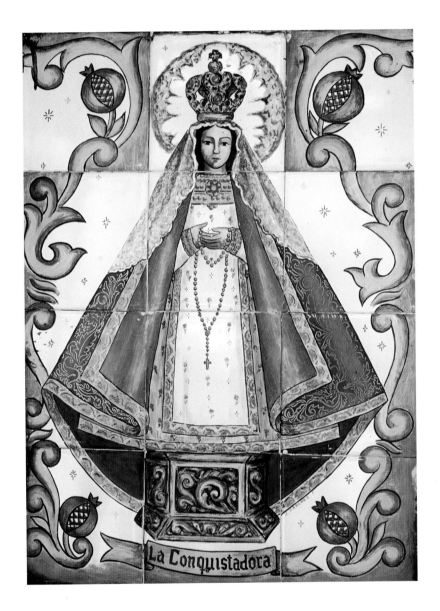

51 LA CONQUISTADORA

early 20TH C., Santuario de Chimayó, New Mexico,
ceramic tile

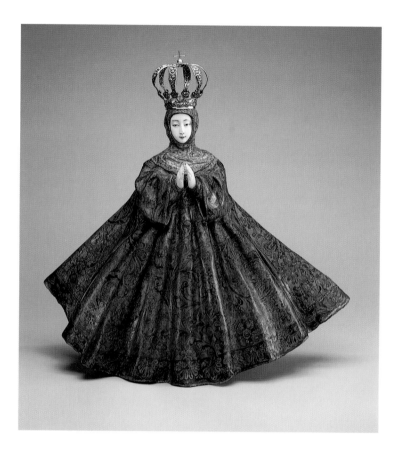

52 VIRGIN
18ᵀᴴ C., Hispano-Philippines, ivory, polychrome,
gessoed cloth, silver

53 MARY IN CHINA
early 20ᵀᴴ C., China, ink and watercolor
on handmade paper

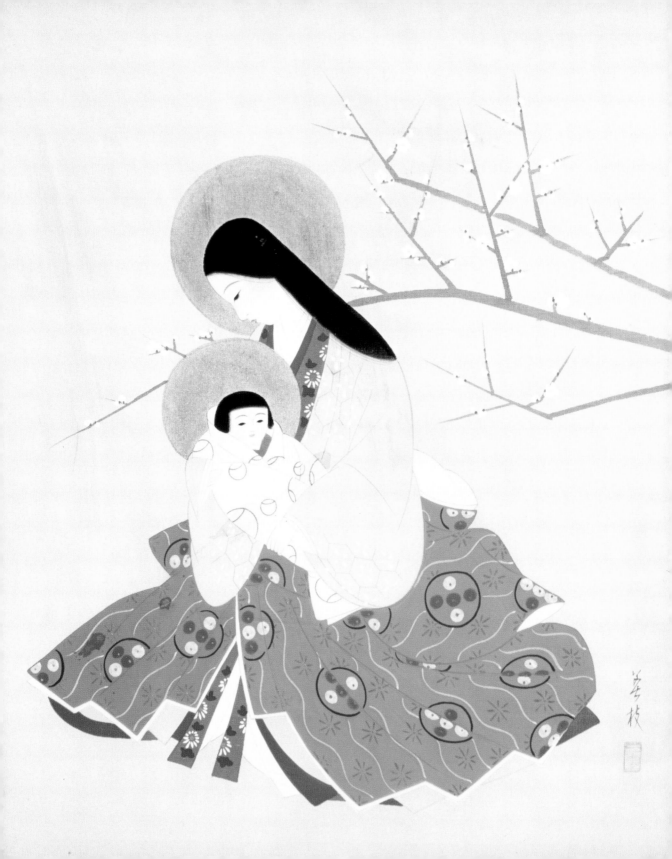

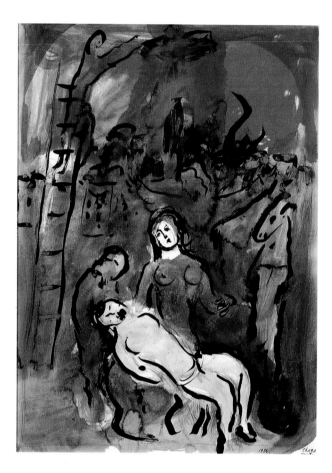

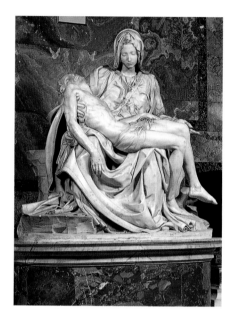

55 PIETÀ
Michelangelo Buonarroti
16TH C., St. Peter's Basilica, Vatican City,
polished marble

54 THE RED PIETÀ [PIETÀ ROUGE]
Marc Chagall
1956, Russia, medium not given

56 THE VIRGIN IN THE COURTYARD
Martin Schongauer
late 14TH C., Germany, engraving

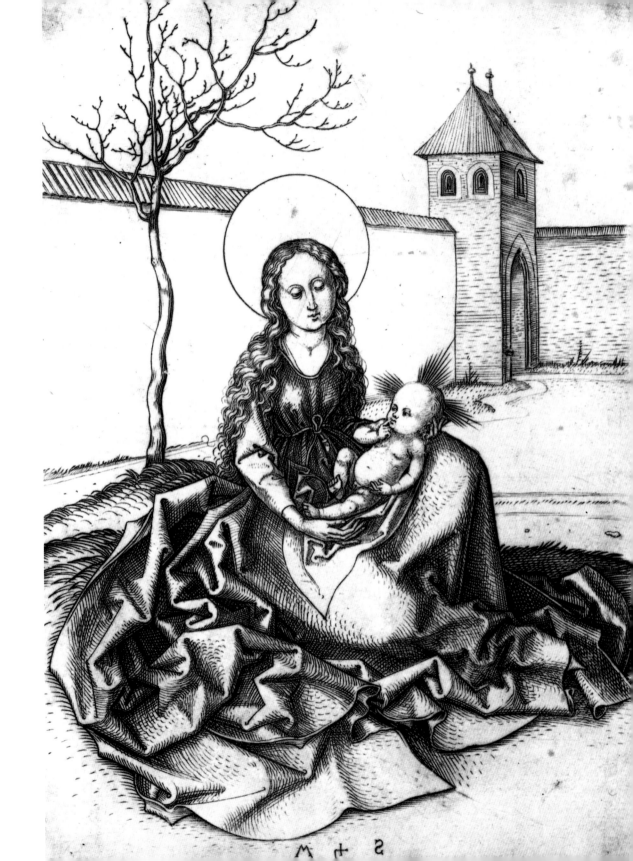

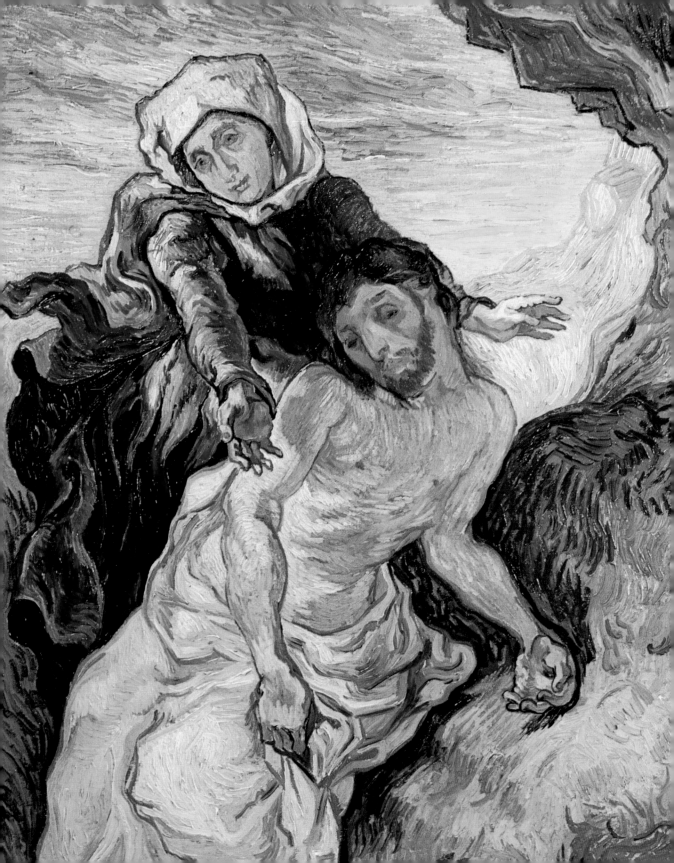

Now there stood by the cross of Jesus his mother... When Jesus therefore saw *his mother,* and the disciple standing by, *whom he loved,* he saith unto his mother, Woman, behold thy son!

57 PIETÀ *[after Delacroix]*
Vincent van Gogh
1889, Netherlands, oil on canvas

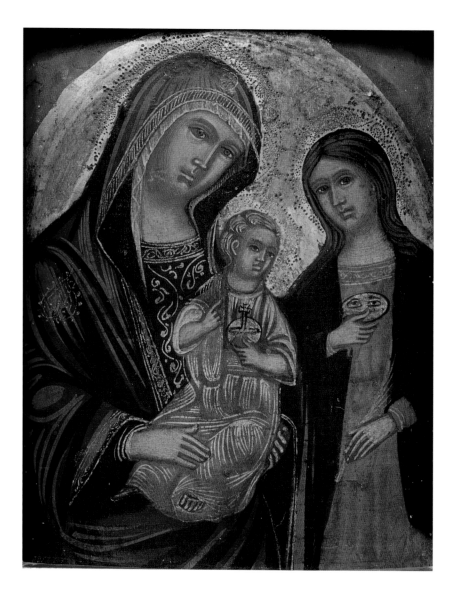

58 MADONNA WITH SANTA LUCIA
AND THE INFANT JESUS
ca. 1500, Italo-Byzantine, pigments and gold on wood

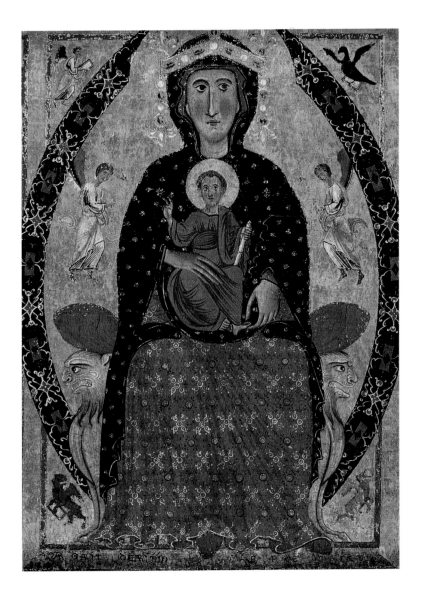

⁵⁹ THE VIRGIN AND CHILD ENTHRONED
Margarito di Arezzo
13TH C., Italy, medium not given

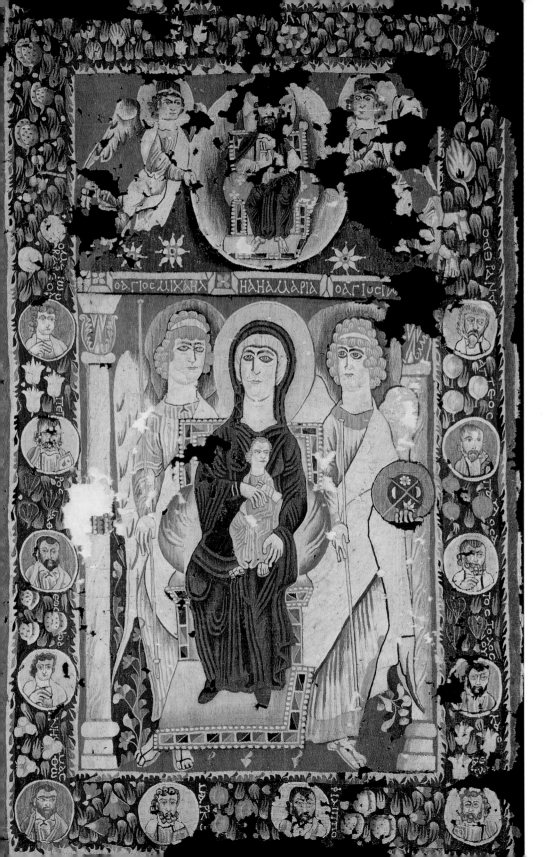

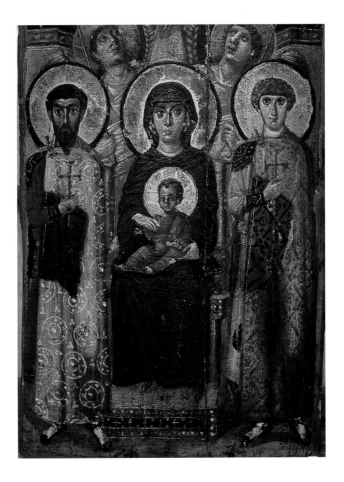

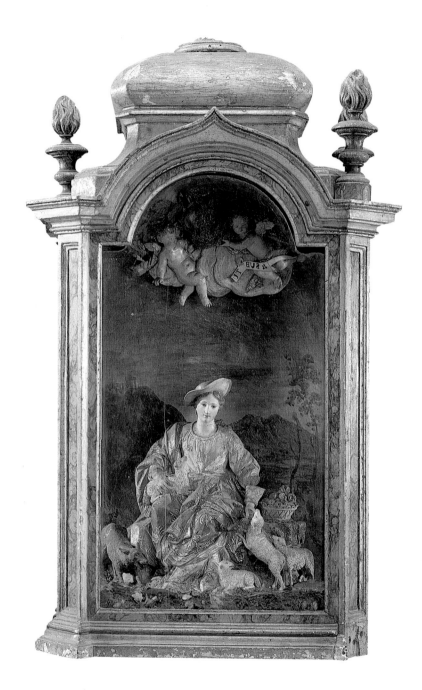

62 VIRGIN AS GOOD SHEPHERDESS
late 18ᵀᴴ C., Portugal, polychromed terracotta
with gold leaf in wooden shrine

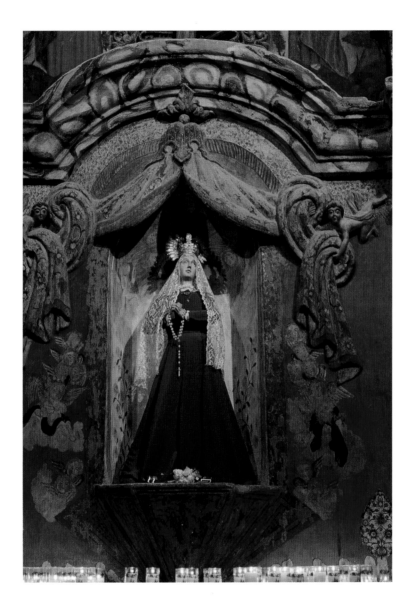

63 LA DOLOROSA [MARY AS THE SORROWING MOTHER]
late 18ᵀᴴ C., Mission of St. Xavier del Bac, Arizona,
painted, carved wood, cloth garments, rosary

AND MAR SAID

And Mary said,
*My soul doth magnify
the Lord,*
And my spirit hath
rejoiced in God my
Saviour.

64 VIRGIN OF THE IMMACULATE
CONCEPTION
Francisco de Zurbarán
ca. 1638, Spain, oil on canvas

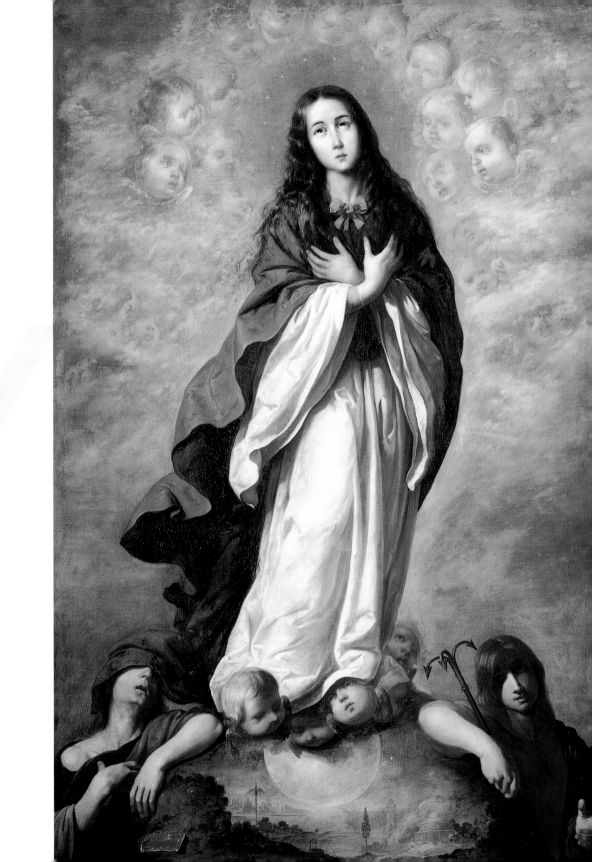

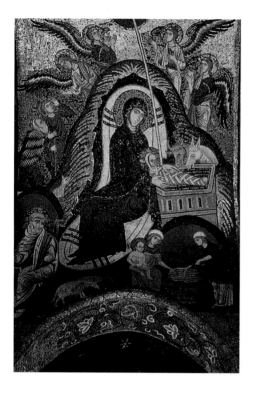

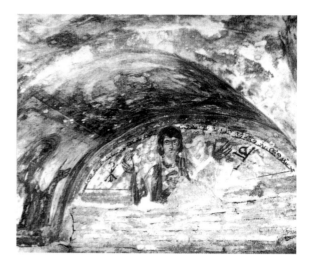

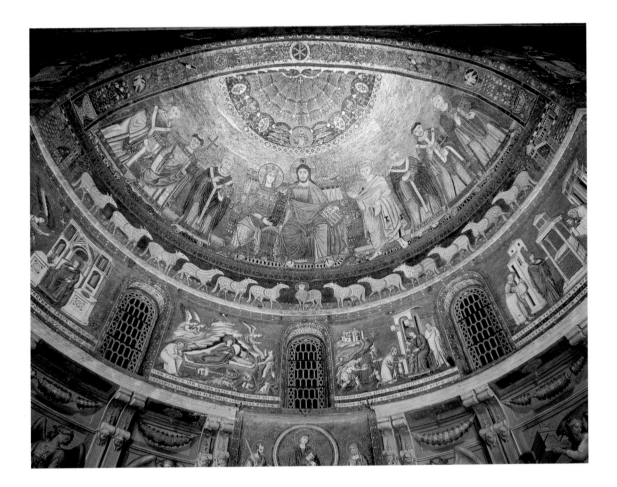

ca. 1143, Santa Maria Trastevere, Rome, Italy, mosaic

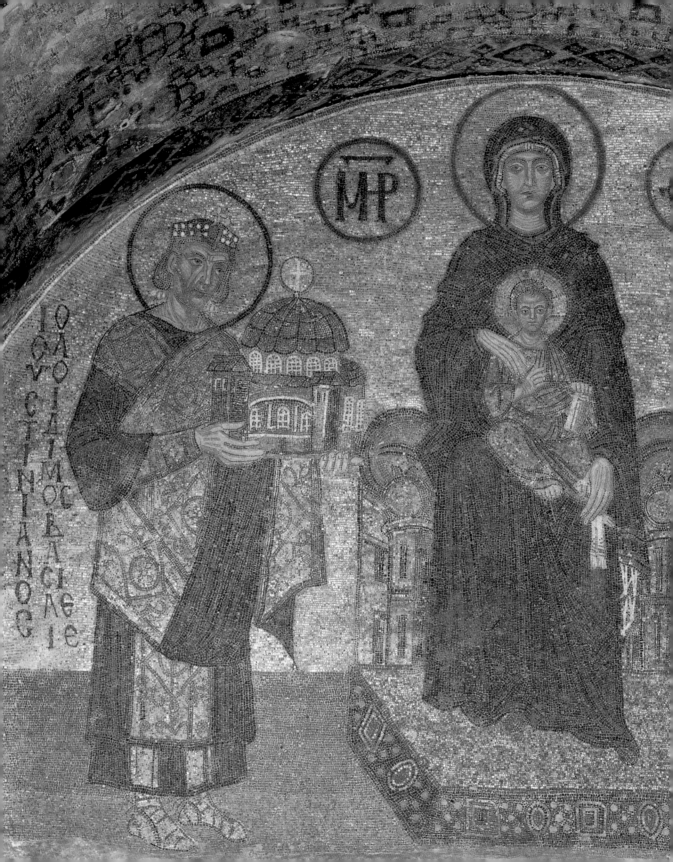

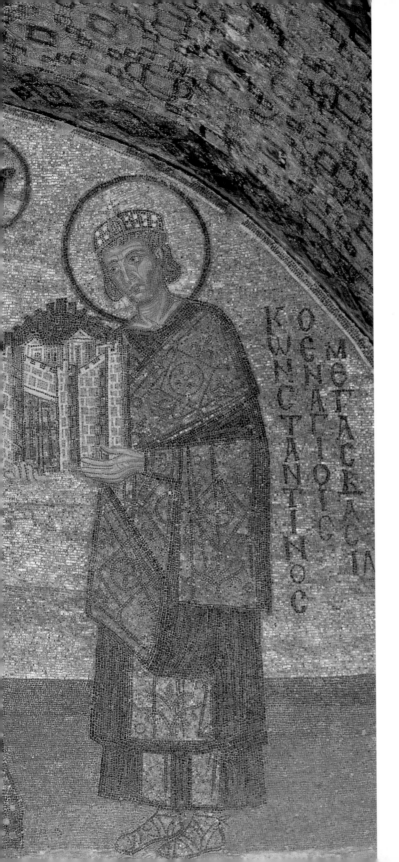

68 MADONNA AND CHILD FLANKED BY
EMPEROR JUSTINIAN
AND EMPEROR CONSTANTINE
early 10ᵀᴴ C., Hagia Sophia, Istanbul,
Turkey, mosaic

69 MADONNA OF THE IMMACULATE CONCEPTION
19ᵀᴴ C., Guatemala, polychrome wood
with crown of punched tin

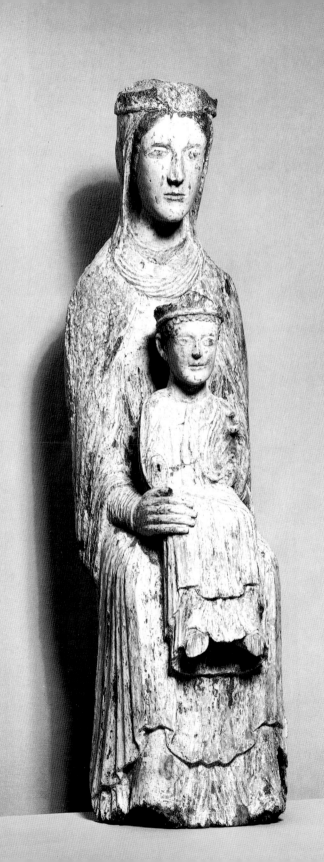

70 MADONNA AND CHILD
early 13TH C., France, carved walnut with
paint traces

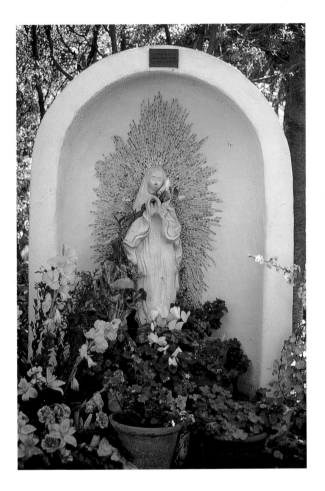

71 MADONNA OF THE GARDEN
20ᵀᴴ C., Mission San Diego de Alcalá, San Diego,
California, plaster and mosaic

72 MADONNA IN THE GARDEN
20ᵀᴴ C., Christchurch, New Zealand, carved stone

Cycle of Major Feasts and Celebrations

January 1 SOLEMNITY OF MARY, MOTHER OF GOD

February 11 MEMORIAL OF OUR LADY OF LOURDES

March 25 SOLEMNITY OF THE ANNUNCIATION

May 13 FEAST OF OUR LADY OF FATIMA

May 31 FEAST OF THE VISITATION

June [date varies] FEAST OF THE IMMACULATE HEART OF MARY

August 15 SOLEMNITY OF THE ASSUMPTION OF THE VIRGIN MARY

August 22 MEMORIAL OF THE QUEENSHIP OF MARY

September 8 FEAST OF THE BIRTH OF MARY
 FEAST OF OUR LADY OF CHARITY

September 15 MEMORIAL OF OUR LADY OF SORROWS

October 7 MEMORIAL OF OUR LADY OF THE ROSARY

November 21 MEMORIAL OF THE PRESENTATION OF MARY

December 8 SOLEMNITY OF THE IMMACULATE CONCEPTION

December 12 FEAST OF OUR LADY OF GUADALUPE
 [LATIN AMERICA AND USA]

Sources of Text

Introduction pages

★ McBrien, Richard P., general editor. *HarperCollins Encyclopedia of Catholicism* (HarperSan Francisco, 1995). General data.

★ Pacheco, Francisco. *Arte de la Pintura, 2 vols.* E. J. Sanchez Cantón, editor (Madrid, 1956)

★ Pope Paul VI. *Marialis Cultus (Devotion to the Blessed Virgin Mary).* Adapted from *L'Osservatore Romano* (Washington, D.C., 1974).

★ Pope Pius IX, *Ineffabilis Deus Munificentissimus (Dogma of the Immaculate Conception).* Proclaimed: Vatican City, 8 December, 1854.

★ Pope Pius XII, *Munificentissimus Deus (Dogma of the Assumption of the Virgin Mary).* Proclaimed: Vatican City, 1 November, 1950.

★ *Protoevangelium Jacobi.* Cartlidge, David R., and David L. Dungan, *Documents for the Study of Gospels* (Philadelphia: Fortress Press, 1980)

★ *Pseudo Melito.* Cited by Marian Warner, *Alone of all Her Sex* (New York, Alfred A. Knopf, 1976, pp. 85–6).

Plates

p. 23 Luke 1:30
p. 30 Luke 1:31, 1:34
p. 38 Luke 1:42
p. 47 Luke 1:48
p. 57 Luke 2:7
p. 67 Luke 2:34–2:35
p. 77 John 19:25–19:26
p. 84 Luke 1:46–1:47

All quotations from the Bible are from the *King James Version*.

Sources of Illustrations

Introduction pages

p. vi Copyright the Frick Collection, New York
p. viii Art Resource, New York. Eric Lessing, photographer
p. xiii Photograph © Jack Parsons. Spanish Colonial Arts Society, Santa Fe. Bequest of Alan and Ann Vedder

Plates

1 Courtesy of the Nelson-Atkins Museum of Art, Kansas City, MO (F83-55)
2 Art Resource/Sapieha, New York
3 Copyright the Frick Collection, New York
4 Courtesy of the Denver Art Museum Collection (1983.598), Gift of Dr. Belinda Straight
5 Art Resource, New York
6 Art Resource, New York
7 Photograph © Jack Parsons. Spanish Colonial Arts Society Collection, Santa Fe. Bequest of Alan and Ann Vedder
8 Art Resource, New York
9 J. Paul Getty Museum, Los Angeles (84.ML.84, Ms.4)
10 Art Resource, New York
11 Fitzwilliam Museum, Cambridge, England (560, Vanni)
12 Art Resource, New York
13 Art Resource, New York. Eric Lessing, photographer
14 Art Resource, New York. Eric Lessing, photographer
15 New Orleans Museum of Art (74.266)
16 Art Resource, New York
17 Art Resource/Alinari, New York
18 Henry Moore, British, 1898–1986. *Madonna and Child.* Pencil, white wax crayon, watercolor, black crayon, pen and black ink, 22.5 x 17.5 cm. © The Cleveland Museum of Art, 1999 Hinman B. Hurlbut Collection, 313.1947
19 Patrick and Beatrice Haggerty Museum of Art, Marquette University, Milwaukee, Gift of Mr. and Mrs. Ira Haupt (59.9)
20 Photograph © Board of Trustees, National Gallery of Art, Washington, 1999, Samuel H. Kress Collection (1939.1.290.(401) / PA
21 Art Resource, New York
22 Metropolitan Museum of Art, New York, Bequest of Sam H. Lewisohn (51.112.2)
23 Otto G. Richter Library, University of Miami, Coral Gables
24 Photograph © Charles Mann
25 Art Resource/Scala, New York
26 Cuzco School, Peru, ca. 1740. *Sacred Family with Holy Trinity.* Oil on canvas, 39 x 60½ inches. Courtesy Denver Art Museum, Gift of Mr. and Mrs. Philip W. Amram, 1979.182
27 Photograph © Board of Trustees, National Gallery of Art, Washington, 1999, Samuel H. Kress Collection (1.256. (367) / PA
28 © National Gallery, London, England (NG752)
29 Photograph © Board of Trustees, National Gallery of Art, Washington, 1999, Rosewald Collection, (1943.3.565.(B-3120) / PR
30 Courtesy of Metropolitan Museum of Art,